S0-AJB-023

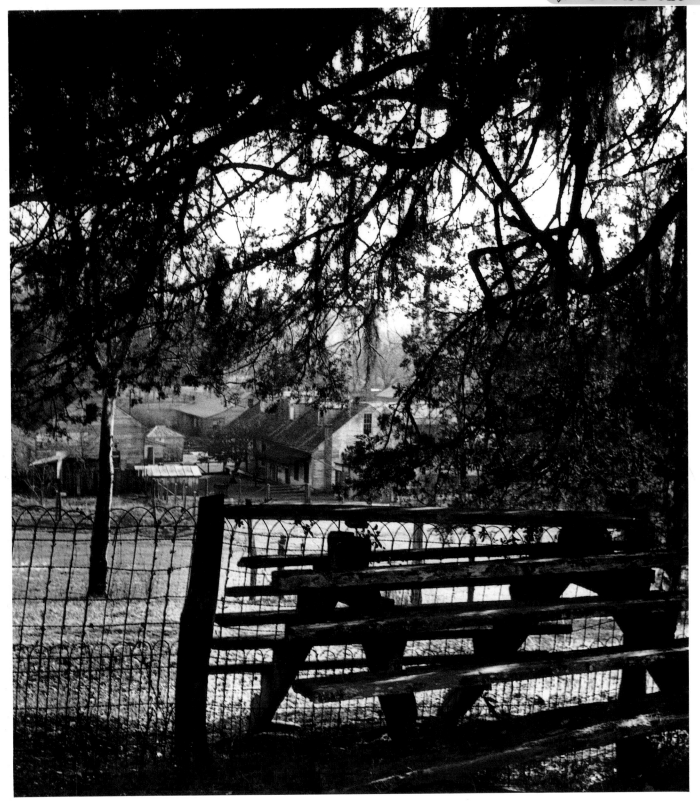

WITHDRAWN

Eudora Welty

Photographs

FOREWORD BY REYNOLDS PRICE

UNIVERSITY PRESS OF MISSISSIPPI / JACKSON

Introduction copyright © 1989 by the University Press of Mississippi

Foreword copyright © 1989 by Reynolds Price

Photographs copyright © 1989 by Eudora Welty

Manufactured in Japan by Toppan Printing Co.

Third Printing 2001

The paper in this book meets the guidelines for permanence and durability of the Committee on Production Guidelines for Book Longevity of the Council on Library Resources. ∞

The University Press of Mississippi thanks the Mississippi Department of Archives and History for permitting the reproduction of the Welty photographs selected from its collection for publication in this book.

Designed by Richard Hendel

The publisher gratefully acknowledges the cooperation of Gil Ford Photography, Inc. for making the photoprints.

British Library Cataloguing-in-Publication data available

ISBN 0-87805-529-0

CIP 89-35218

Frontispiece:

Cemetery stile / Rodney / 1940s

Contents

I would like to acknowledge and express deep indebtedness to the Mississippi Department of Archives and History for their preservation of and care for the photographs and negatives deposited in their possession. For their generosity and unstinting aid to the editors in the making of this book, I thank on my own account Mr. Elbert R. Hilliard, Director, Mr. Hank T. Holmes, Director of the Library Division, and Ms. Patricia Carr Black, Director of the Mississippi Historical Museum. My particular gratitude goes to Dr. Suzanne Marrs, who while Welty Scholar-in-Residence at the Archives identified, organized, and filed all the existing prints and negatives in this collection, from which most of the contents of this book are drawn. And I express again my deep and ongoing gratitude to Ms. Charlotte Capers, former Director of the Archives, who conceived the collection and first installed it, and to whom the initial book of my photographs, *One Time, One Place* (Random House, 1971) was appropriately dedicated.

Eudora Welty
May 1989

The Only News
BY REYNOLDS PRICE

The eye is sovereign in every art but music. Reading, writing and painting are all but soundless deeds of sight. Great mimes demonstrate the force of mute gesture; even dancers can move to unheard rhythms. But the first of all their sources and targets is the human eye. Their own quick eye consumes the world, works mysterious transformations and beams it on to the eye of their beholder. Every artist I've known – and here I include composers – is a ceaseless watcher of visible nature. They pay close attention to the crowd of things and creatures that surrounds us all day and that we reshape, for unknown reasons, at night in dreams and nightmares. In tragic contrast, a great many people are blind all their lives, the worst of human curses. John Ruskin found the core of the flaw and the loss it entails in all generations:

> The greatest thing a human soul ever does in this world is to *see* something, and tell what it saw in a plain way. Hundreds of people can talk for one who can think, and thousands can think for one who can see. To see clearly is poetry, philosophy, and religion – all in one.

If the claim seems excessive, if you think most men and women are visually attentive, test yourself soon in a public place. Sit on a bench apart from the movement and watch for a while. Barring a sudden wreck or fight, you're more than likely to see that most people move with a functional near-blindness, especially in cities. Every now and then, a watcher appears – the man who pauses to study a legless beggar, the woman who crouches to speak with a stray cat. But the mass are safe, from surprise and discovery, in the opaque tubes down which they hurry. More than once I've spotted a famous face in a crowd – in an airport, say, and a glamorous face that looked exactly like its world-famed self – and no one else even glimpsed its passing.

Surely it's a born intensity of witness, a mysterious urgent need to *watch,* that first marks out the possible artist – the quiet child on the fringe of the playground, not necessarily rejected or sad but somehow committed to life as a spy, a benevolent underground operative. Think too of those few children who quickly move, with no sense of motive, from the bold mess of nursery drawings to a cooler try at representation. *I must copy the world or this piece of it in the hope of remembering, praising, amending and controlling its face.*

Thus many writers and dancers have drawn and painted strikingly; many painters, sculptors, filmmakers, dancers and actors have written memorably. The drawings and paintings of Goethe, Blake, Ruskin, Rossetti, William Morris, Hopkins, Cocteau and even Nijinsky are rapt reports on the surface and depths of reality. The letters, journals and memoirs of Delacroix, Van Gogh, Gauguin, Karsavina, Nijinsky again, Chaplin and Jean Renoir make images as clear, persistent, disturbing and useful as their pictures or gestures. And in the past fifty years, well into the age of the camera, more than a few writers, painters and photographers have crossed and recrossed the charged highwire between word and image.

In America alone since the First World War, we've had the photographs of the writer Wright Morris and the painter Ben Shahn; we have the writings of Edward Weston, Ansel Adams, Aaron Copland, Georgia O'Keefe and Martha Graham. In every case, the crossover words or pictures do better than stand on their own feet as live and

arresting in their own lucid right, while they also enrich our response to the artist's chief line of work. And in recent years we've seen a few of the hundreds of photographs made in Mississippi and elsewhere from the 1930s on into the fifties by one of our most comprehensive writers.

Eudora Welty's first book was a collection of stories, *A Curtain of Green;* it appeared in 1941. Its earliest story, "The Death of a Traveling Salesman," was written in 1936; so a number of the pictures included in this volume precede her first published work. In a preface to *One Time, One Place,* her earlier and smaller collection of photographs, Welty explained that her years of snapshooting in rural and smalltown Mississippi were among the forces that brought her to the realization that her prime compulsion was to push beyond the silent voice of image to the stronger but slower voice of words. (She has often insisted that her pictures are *snapshots*; and the word does define both the frozen moment she always sought and the absence of any trace of pretension to studied art.) She had written occasional fiction since childhood; but some steady mystery in the world before her, some gulf that deepened in the early years of silent watching, was moving her toward another angle of vision as her ultimate foothold.

In my own case, a fuller awareness of what I needed to find out about people and their lives had to be sought for through another way, through writing stories. But away off one day up in Tishomingo County, I knew this anyway: that my wish, indeed my continuing passion, would be not to point the finger in judgment but to part a curtain, that invisible shadow that falls between people, the veil of indifference to each other's presence, each other's wonder, each other's human plight.

It's famous by now that the stories came, and in torrents, soon. The first were brief, deep as knife thrusts, though meant to heal. Then came a novel, then longer stories, then more of each till she'd made a great hill of work, still growing. The names, people, places and actions of her fiction are as weighty a piece of our legacy now as the work of any artist, statesman or other citizen, living or dead. And while almost invariably her narratives work to lift, even to tear, the scrim that hangs between our solitary lives and the needful world, it's useful to see that the line of vision in all her words remains very near to the one held toward us in all these pictures – some part of the actual world observed by the eye and mind of a single beholder: the just, unblinking but merciful gaze of a born onlooker.

I say *merciful* in full knowledge of the camera's native tendency to blur the raw truth, however scalding and cruel its name. Photography was not yet thirty years old when, in America at least, the Civil War lent the camera its first great subject – the gnarled nobility of Lincoln, the elegant beauty of Lee (and the threat of wildness in his eyes and mouth), the stunned faces of schoolboys torn from home and mother and raced toward death, their slaughtered bodies at Antietam and Shiloh like frozen dolls flung down by idiot gods, exhausted with play. I can think of no more than a small handful of photographers other than Eudora Welty who so much as raise the notion of mercy – *tenderness* surely, *desire, scorn, praise* and *worship* but hardly *mercy.*

Notice though how many of Welty's subjects face her, her eye and the lens, with patent trust. In the numerous images where her subject is conscious of the camera, there are smiles, laughs, inquisitive stares, even comic threats. But nowhere do I see the trace of an emotion more troubled than self-possession. Welty speaks, in the interview here, of the stubborn valor with which her subjects were meeting their lives in a chronically impoverished state, with an international Depression around them.

The many black people are less than a century from slavery – one or two of the older men and women here may have been born as human possessions – and even this far past Emancipation in the 1930s, all are still shut out of most civil freedoms. Most of the white

people are visibly poor; yet like the black brothers, whose kinship they don't acknowledge, they plainly navigate the shoals of time and place with a lightly worn dignity that lasts through weather no fine clothes could bear. Welty's stories and novels make it abundantly clear that she also saw the human and natural evils and trials that pressed her people so fiercely down. But behind a camera, her eye chose images of courage, persistence and the unslaked thirst for more of life.

Since I was reared in the thirties and forties, eight hundred miles north, in a Carolina country and village world much like Mississippi, I well understand how younger viewers from other parts might strongly object to my reading of the pictures. I can easily see that – faced with black people like those in "Home, Jackson" (photograph 61) or with white people as nearly defeated as the woman in "Home, Claiborne County" (photograph 11) – a decent response must include strong portions of sympathy and passionate care, if not outrage.

But since I'm a veteran of the world portrayed here, I can join with Welty in confirming the fact that crowds of these same oppressed human creatures could quickly summon a vibrant strength and a joy in the cruel but giving world that burns in so many of the other black faces here, so many white faces strong as plow points. (It's easy to state the glaring corol-lary – for good and bad, these adverse fates and the people who bear them are visible in many of the same hard forms today, in the South and elsewhere, though seldom with this cool air of trust.)

In the years of the bulk of these pictures, as she tells us, Welty worked with a Federal agency, the Works Progress Administration. She traveled her state as a public-ity agent, writing of people who were making do in the teeth of the Depression – gardening, quilting, building airports, stocking book-shelves, teaching illiterate adults to read. In her job then, she was see-ing the doers, the self-propelling souls. But whenever she raised the lens, for her own sake, she subtly shifted to the left of her job and far to the left of her own home knowledge.

What she captured, once and for all, were not the small public victo-ries of groups, the state-fair exhib-its of gourds and calves, but the larger private triumphs of man, woman, child as – moment by moment – they won their lives against time, fate and human oppo-sition. Time and again she evoked and held for our benefit that rare moment when a human mind agrees to part its doors and show the deep sanctum where all its losses and hopes are stored. No stop-motion film of an orchid blooming in full moonlight is more rewarding, more worth that wait.

In the same day and place, a county nurse or a welfare-claims worker might have shown other angles, dark or bleak, on despair and failure. Vital as such knowl-edge is for completeness, we're never in short supply of its pic-tures. Again the camera, in many hands, has a ravenous taste for pain and blood. But what's on show in this book still is the oldest truest pageant of all – the human will to stand-and-take, upright if possible, whatever comes. And behind the show stands the final secret all watchers know, the amazing fact that most shut minds long to open and bear our gaze.

Think of only the largest prose writers who have lived since the invention of the camera – Dickens, Tolstoy, Dostoyevsky, Chekhov, Flaubert, Conrad, Proust, Mann. Though the equipment available to them was hardly compact, any one of them might have photographed his people and places. There are grandly revealing photographs *of* all of them – I especially prize a snapshot of old Tolstoy out walking with his sister, an Orthodox nun; his smile alone is worth those phil-osophic chapters that slow *War and Peace* – but to my knowledge, there's no real body of photographs *by* one of them.

Think of having Tolstoy's pictures of his family and servants, the mod-els for most of what he knew (his peasant coachman, for instance, was his bastard son). Think of hav-ing Flaubert's portraits of provin-cial wives, embalmed in boredom, or Proust's tableaux of the nature he loved – the parks and churches,

the lacquered ladies and fabulous doormen. Or Conrad's views of Malaya and the Congo, the eyes of the haunted Flying Dutchmen with whom he spent his early life. Or later still, Virginia Woolf's Cornwall or a set of Joyce's Dublin faces. What would we have that we presently lack?

Recall what Conrad said about fiction in his preface to *The Nigger of the Narcissus* – "My task which I am trying to achieve is, by the power of the written word to make you hear, to make you feel – it is, before all, to make you see. That – and no more, and it is everything." Every*thing,* yes, and most writers of fiction work to that end; but most of them, and most honest poets, will admit that the aim is never quite reached. To even the sympathetic reader who works at translating word into image, the best prose only conveys a shadow of the thing really seen. So the intended projection of a world that lives in one mind only, the solitary writer's, is almost inevitably only part-successful and, even then, with only a hard-working reader.

It's not romantic nonsense to locate the narrator's agony there, at that sudden chasm between his word and the reader's racing mind. But assuming a degree of mechanical skill, any of the writers mentioned above might have brought us nearer to the world attempted, if only they'd photographed their external sources. For it's common knowledge that the best photographs, from the raddled face of a

tuberculous Chopin in 1849 to the eyes of a child rescued from danger on the evening news, reach us with an instant indelible force that no prose genius has yet mustered. Eudora Welty has deployed that force abundantly. Few American writers, and few elsewhere, show as large a skill at pictorial precision in words. Aristotle rightly chose, as the prime mark of a poet, the craft of metaphor – a gift for discovering in the world and then for transmitting clearly a stream of likenesses in visible nature. A glance at any page of Welty's fiction is likely to show more than one such yoking of disparate sights in a single image of startling freshness:

> His memory could work like the slinging of a noose to catch a wild pony.

Or deeper still,

> Old Solomon was far away in his sleep, his face looked small, relentless, and devout, as if he were walking somewhere where she could imagine the snow falling.

Before her photographs surfaced widely in 1971, few readers can have felt a need for illustrations of a prose that takes such steady care to build its own pictures. But now that so many of the photographs are available, readers have a new and retroactive companion for a fresh approach to her fiction. Though writers as good as Proust have built whole characters and

scenes on a particular painting or photograph (Botticelli's Daughter of Jethro who becomes Proust's Odette, for instance), it would be easy but dangerous to suggest connections between a given picture of Welty's and one of her stories. Anyone who knows her fiction, and then looks here, will at once spot faces, buildings, children's games, loaded gestures and empty places that throw light back on this or that moment in the narrative prose.

But a saner pleasure comes with a slower look through the pictures in their arresting concentric present order. Watched slowly thus, they offer the chance of learning the face, voice and gestures of a whole new world or at least a chance at excavating lost facts. If you know her fiction, the world you're likely to find herein is a sister-planet to the long verbal dream or a bedrock stratum from which that long dream rises like breath. But suppose a patient viewer knows nothing of her stories and novels, my guess is still that a solid world can be constructed in a willing mind, from just these faces, these moving limbs, the air and light behind them and the acts and feelings that wait to be.

If you were born and raised in the American Southeast before, say, 1950, you'll be led by your memory of similar images to make a story that most accords with your native moral sense, tuned or untuned to the changing world beyond home bounds. Above all, your response

to the apparent poverty of most of the black people, and many of the white, will tell a good deal about your own background and your present hopes. You'll gauge the degree of contentment on these faces – not to speak of a possible joy – in ways that uncover your oldest convictions. If you're from a markedly different place, and the rest of America is still very different, the story you make from this many pictures is entirely unpredictable. Nonetheless it will say as much about you as it will about Mississippi in the Great Depression and a few other places in the next two decades.

It might even be instructive to study them more than once, in several guises. See them as a Catholic priest might, a Marxist intellectual, a radical feminist, the aging son of an emancipated slave, the hundred-year-old daughter of a Confederate soldier, a liberal male politician of the present, a Ku Klux Klansman, a young woman hoping to spend her life taking pictures of the world while she writes about it or a child with a young wolf's hunger for knowledge. The sheer information that's waiting here could keep anyone of those minds at work for a useful time.

I've said that my own early years were spent in places and among people much like these. If I try to set aside my long familiarity with Welty's prose, then with all my training behind me, and the changes worked in that training by time and other places, I might not deduce an actual story but more likely a poem or the feel of the bones in an unseen face, a blind man's portrait of a patient companion who has offered her mind and eyes to me. Assuming that I searched them in their present order – and assuming I was told that all the pictures are from one artist, and she a woman (neither of which I could be sure of guessing) – I'd know this much at least.

She moves with the pace of a masterful hunter, seeking her needs in thickets and fields. She's benignly stealthy and hard to glimpse but she's seldom invisible. When she stops to watch more closely, then to register *her find, she is mostly known to the object of her gaze; or if she's strange, her face and eyes are met with welcome or a dignified generous gaze in return. Despite the signs of destitution – ruined houses, bare ground, the same "looped and windowed raggedness" of "naked wretches" which old King Lear discovers in the storm – not one face in all these pages betrays despair or distrust of the watcher behind the lens.*

And so most kinds of faces respond to her eyes with a trust that turns their hidden skulls translucent; so we see what these defended minds think, in their lonely silence – what they think of themselves. *Whatever their verdict, it is not without mercy; and it never shows hatred or the bile of loathing.*

As she moves through women, men, then children, then through all together in the naked toils of a carnival ground, this watcher's pace grows lighter till soon – in small towns, countryside, lanes and woods – she fades from view and is only an unseen solitary eye in a world of cities, now crowded with equally lonely eyes, now silent and still as any dead planet prowled by creatures so lonely they barely face one another but make a high music as they go their way, untouched, unrewarded.

Then men and women again, strong children and the easy grins of welcoming friends. The whole wide journey ends at home – the brothers who branch from the central tree and the heartwood itself, a man and woman who plainly hail a watchful child back to the port from which all wanderers start for the world and to which no one but the bravest returns.

To be sure, that's an exercise of personal reverie; and it may be a little woolly as a reading of the clean-limbed evidence frankly offered, the patent hard facts in these clear frames. For whenever she's spoken about her pictures, Eudora Welty has defined them as *facts;* and a great many patent facts in her pictures are tragic, though her subjects' awareness of tragic roles is seldom glimpsed. Whatever their pains and grievances, these people never assume the classic postures of defeat, lament or ferocious rage.

In the interview here, Welty says "I was taking photographs of human beings because they were real life and they were there in front of me and that was the reality." A sympathetic watcher can add, "A reality found by you alone and held toward me, in the hope I'll strike a harmonic response." For in a letter to her agent and friend Diarmuid Russell in 1940, she was writing of her stories; but the same impulse is clear in the pictures:

> I am one of those who believe that to communicate is the hope and purpose and the impulse and the result and the test and value of all that is written and done at all, and if that little spark does not come, and with a little sheltering flash back & forth, then it's the same as being left confined within ourselves just when we wished most to reach out and touch the surrounding life that seemed so wonderful in some way.

In the twenty-odd years the camera demanded a piece of her time, Welty employed and shared with unmistakable intensity the same acuity and patience of vision which distinguishes her fiction. Try to imagine these pictures coming from any other writer of the time – Cather, Porter, Faulkner, Hemingway, Steinbeck: all unthinkable, in various interesting ways. In book after book Welty has chosen or accepted the role of an intent observer, unsparing but benign. And behind the lens, in those early days when her hand was only beginning to write, the eye was just as keen and steady and – if possible – even more merciful, as though the breathing fact of a person who stood before her was a solemn trust that must not be betrayed. In no other writer's mind since Tolstoy and Chekhov do I hear a more godly patience humming, like the sound at the hub of an entire galaxy, circling the night.

Other photographers, with ampler lenses and studied craft, were working nearby toward different findings. In the well-known pictures of Walker Evans in Alabama, the faces of poor white families burn with a bitter adamance – or are stunned and frozen – in a way not seen in Welty's pictures. And among the hundreds of images, strong as pleas or weapons, from those photographers employed by the Farm Security Administration in the thirties and forties, Dorothea Lange's eloquent findings show forever those dispossessed white Southern farmers – men, women and children – who stand, if only for that one instant, and face their driven fate in a baffled pain too naked to watch without some futile longing to help them.

But no one else from that full time, no one known to me, has gathered a broader body of vision. Set down here so carefully, it can now be seen as the large reward of a hungry fearless patience, all charged with the burning hope of transmission – from the active seer's world-roaming eye to the eye of the equally solitary watcher at home. What it will mean to him or her – now or a hundred years from now, on whatever planet – is unthinkable surely. But if future minds have not lost all blood-kinship with ours, the pictures here will go on bearing clear witness to a time and place much like all others, where life is lived in bolted rooms called *men, women, children* to which the only passkey is impassioned care – the calm assurance that their lone plight is seen in earnest and deeply shared and told to others, the only news.

Introduction
EUDORA WELTY AND PHOTOGRAPHY: AN INTERVIEW

You call the published pictures in One Time, One Place snapshots and called it a snapshot album. Why do you consider them snapshots and not photographs?

Well, they were snapshots. It refers to the way they were taken, which gave meaning to the book. They were taken spontaneously – to catch something as I came upon it, something that spoke of the life going on around me. A snapshot's now or never.

What camera did you use?

I started with a small Eastman Kodak with a bellows, that used Number 116 film. It wasn't expensive, but it had a good lens, and a shutter which I remember allowed for 1/25th and 1/50th and 1/100th of a second exposure and time exposure. I could really see the 116 negatives before I printed them or made enlargements – I could learn from the mistakes I'd made.

And you used other cameras?

As time went by. One was a mistake. I bought a Recomar which used a film pack. Another Eastman Kodak, it was large and expensive and for me it proved unhandy. One time in New York I took it and sold it back to the same place I bought it. Then later I was able to buy a

Rolleiflex, which in these times, of course, would be unaffordable.

And you preferred it above the others, of course?

It was above all. Mainly for the wonderful ground glass viewfinder, which was the exact size and shape of the picture I was going to take. So that I got a sense of composing a precise picture, and the negatives were lovely to work with. All this time I was printing my own, after I had the film developed at Standard Photo. My brother Edward made me a contact exposure thing like a little box frame. Then I got an old castoff enlarger from the Mississippi Highway Department. I set up a darkroom in my kitchen at night with a red light to work by, and the enlarger clamped on the kitchen table. It had only one shutter opening – wide open – and the only way you could control or graduate the exposure was by timing it, which you could learn by doing.

Once when I was in New York, I went into a camera shop, Lugene's on Madison Avenue, to buy some supplies and saw the owner had an exhibition around the room of an amateur's photographs, prints that were made there. So I wondered what he would think of mine. And he looked at my pictures and

decided to show them. He supplied me with a lot of stuff that I never knew about – better paper, chemicals, and things like that. He was helpful, too – he marked on each one what was wrong, like not enough contrast, too much, and so on. And so I printed up a collection of the best ones for him, and he did exhibit them, as you probably know, and a little program too. I read here the reason he showed them was that they had been printed in Mississippi under "primitive conditions." And I realized that all this time I had been a "primitive."

How were those pictures received in the North?

I doubt if anybody knew the difference. They wouldn't have been reviewed. It wasn't a gallery, it was a shop, and even if reviewers had seen the show, they would have found it enough to say that here are primitive pictures by an unknown from Mississippi.

Was it your father and his love of mechanical instruments that interested you in photography?

I suppose indirectly. The pictures he was taking were mostly of us, but we were hardly conscious of that. I do remember being allowed

to handle his camera. He had a nice Eastman camera with a bellows that pulled out a good long way. He made the exposure by pressing a little bulb, as I remember. It took postcard-sized pictures. I learned much later on that he'd had other cameras that produced different-sized photos – I found the negatives he had made. He and my mother used to develop them and print the pictures at night, before we children were born, my mother told me. Domestic scenes, early in their marriage – Mother putting up her hair, Daddy reading. They charm me.

Didn't he encourage some entrepreneur to develop a camera store or a photography shop in Jackson?

He did – when the Schleuters came to Jackson. My father's insurance company, the Lamar Life, was then a little Greek edifice, if you remember, with columns, on Capitol Street, near Mrs. Black's grocery store and the Pythian Castle. On its other side was a vacant lot. The Schleuters came in and asked my father about it and he was interested because he liked photography and because they were two brothers, young and starting out in a strange place. He did encourage them, I don't know in what way. And they started Standard Photo Company, built on the vacant lot, and made a success. They did my pictures all through the years, and advised me and were good friends.

When your pictures were printed, did they give a surprise? A good one or a bad one? You know that various camera lenses have personalities? Did you detect that when you were printing your pictures?

Well, I had only a single lens in those days, you know. I just thought: that was the lens. After I got the Rolleiflex, the only other lens I bought was a portrait attachment, which I didn't use too much because I like showing background, a long perspective, in the kind of portraits I attempt. I wanted to set people in their context. And I think I had a cloud filter; but that's all. I never used lights. I'm not in any sense of the word a professional. I just wanted to get the subject and play with it afterwards; cutting and enlarging and so on, I find my composition. Let it show what was inherent in it.

When you were traveling and taking photographs, you really began to see the state in which you lived. Would you say that your experience with photographs heightened your sense of place?

I think it did. I think the same thing that made me take the pictures made me understand the pictures after I saw them, the same curiosity, interest. I've always been a visual-minded person. Most of us are. I could see a picture composing itself without too much trouble when I started taking landscapes and groups and catching people in action. Practice did make me see

what to bring out and define what I was after, I think.

As you reflect on your pictures, what do you see in them now after all these many years?

I see a record. The life in those times. And that's really why I thought *One Time, One Place,* in 1970, would make a book. It stands as a record of a time and place.

You have said that a camera is a shy person's protection and that you came from a sheltered life, but you've had the spirit of daring required of an artist. Would you comment on how a shy person such as you took some of these daring photographs?

Well, the daring I meant was referring to my writing instead of photography, but also I think my particular time and place contributed to the frankness, openness of the way the pictures came about. This refers to both the photographer and the subjects of the photographs. I was never questioned, or avoided. There was no self-consciousness on either side. I just spoke to persons on the street and said, "Do you mind if I take this picture?" And they didn't care. There was no sense of violation of anything on either side. I don't think it existed; I know it didn't in my attitude, or in theirs. All of that unself-consciousness is gone now. There is no such relationship between a photographer and a subject possible any longer.

Why is that?

Everybody is just so media-conscious. Maybe it's television. Everybody thinks of pictures as publicity or – I don't know. I wouldn't be interested in doing such a book today, even if it were possible. Because it would assume a different motive and produce a different effect.

What did the pictures teach you about writing fiction? Did they teach you anything?

Nothing consciously, I guess, or specifically. I was writing all this time, but I think perhaps a kindred impulse made me attempt two unrelated things – an inquiring nature, and a wish to respond to what I saw, and to what I felt about things, by something I produced or did.

Did they teach you anything about perception or anything about technique?

I'm sure they taught me about the practice of perception and about technique, but the lessons were not in the abstract. Some perception of the world and some habit of observation shaded into the other, just because in both cases, writing and photography, you were trying to portray what you saw, and truthfully. Portray life, living people, as you saw them. And a camera could catch that fleeting moment, which is what a short story, in all its depth, tries to do. If it's sensitive enough, it catches the transient moment.

You studied studio art, you painted, you sketched. In these, do you suppose, as perhaps with photography, that you were searching for a way to reach your calling as a writer of fiction?

I don't think so. My way to learn writing was through writing, from the start, and I did write in strict concentration. It may have occurred without my knowing it that the two interests cooperated in their own way, but I wasn't thinking about either writing or photography except through the doing. Technique springs out of the doing; there's something in the heart of a given story that tells me how to do it and do that only. It's *after* the fact of writing a story that I realize what it has taught me.

It was during one of your WPA trips that you discovered you were truly a writer. In Tishomingo County, Mississippi.

Well, I assigned it there because that is the furthest in Mississippi I ever went. I didn't have a blinding moment of revelation. But just when I was working on *Losing Battles*, a novel set in that part of the world, so much came back to me of what I had absorbed. It was so remote from anything I knew in Jackson or had seen in the Delta or on the Coast or in the Black Prairie country, or any of the other parts of Mississippi where I've been. It

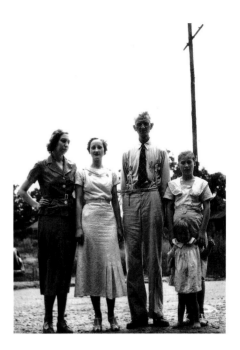

Eudora Welty, WPA Junior Publicity Agent (left), while traveling through rural Mississippi meets a Rankin County family.

appealed to me as a stage to put *Losing Battles* on because life there had been so whittled down to the bare bones of existence. No history but the struggle to keep alive. What was life but family? I was trying to describe what the characters' lives were like without benefit of any editorial comment at all, or any interior description. I wanted things shown by speech, by action, and by setting, location. And characters to reveal themselves and each other by conversation – action and conversation. I confined it all within a big family reunion, to a time length of two days and the night between. Plus the essential flashback.

That technique is very much like in photography?

Except that what is shown is selective. Chosen, specific, pertinent, and thus revelatory.

There is no interpretation in a photograph. It's the viewer who interprets it, and what you've described as your technique in Losing Battles *seems very much like a photograph.*

There's a profound difference. The writer interprets before it can begin. Writing fiction, I am interpreting every minute, but always by way of the characters' own words and acts. My usual method of narration is more introspective; I am in the characters' minds all the time. So I was trying to see if I could do without any of it. It proved to be the most difficult novel I think I ever wrote.

As in a story, your photographs have a trace of mystery. In your essay on Chekhov you said that "the very greatest mystery is in unsheathed reality itself." Is this "unsheathed reality" what your photographs were exposing?

That's too abstract for me. No technique was set forth in my mind. I just wanted to capture a moment and use the right light and take advantage of what I saw.

The young girl in your story "A Memory" composes the intractable world by looking at life through a frame she makes with her fingers. In your essay "Place in Fiction" you

say, "Place to the writer at work is seen in a frame . . ."

It is.

". . . not an empty one, a brimming one." Do you recognize the close alliance of photography and fiction writing in your use of a frame?

A frame is fundamental to both, for me. I was conscious of that when I was getting my pictures, at least when I was printing the results. I knew I needed a frame. Well, when I took art from Mrs. Hull [Marie Hull, Jackson painter and teacher], she taught us that device: framing with your fingers. Studying drawing and painting made me aware in writing a story of framing your *vision,* as a way toward capturing it.

When taking a picture, what was your own personal technique in framing an image? Do you recall any?

Using the viewfinder. That's why I liked the Rolleiflex. You see exactly what you are taking, and in the same size.

Have you ever relied upon any of your photographs for a scene or an element in a story you've written?

No. The memory is far better. Personal experience casts its essential light upon it.

I'm thinking of the suspension bridge in Losing Battles, *or . . .*

It was the bridge itself that made

me think of it in fiction. It was having been on it. It also made me want to photograph it and show the dramatic quality of it.

Do you think that maybe some scenes, the Mardi Gras scene in The Optimist's Daughter, *for instance, are subconsciously a reflection of one of your Mardi Gras photographs?*

Not as a reflection; I've seen it directly in life. But I went back and looked up my photographs after I had written this to get some exact costume that I could give a person. You can't *make up* something fantastic. So I used in the way I might refer to notes, certain snapshots of costumes, but it was the Mardi Gras itself, the living experience, working in my imagination, that made me put it in the story in the first place. My fiction's source is living life.

You said of the pictures in One Time, One Place, *"I did not take these pictures to prove anything." But the photographs do prove something, don't they?*

I think I meant "prove" editorially. *Let Us Now Praise Famous Men,* for instance, was entirely different in motivation from my own photography. I was taking photographs of human beings because they were real life and they were there in front of me and that was the reality. I was the recorder of it. I wasn't trying to exhort the public. When I was in New York during

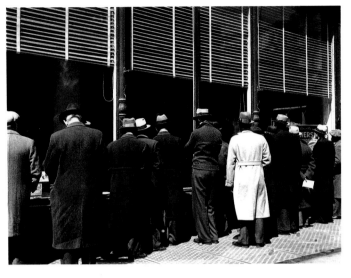

The unemployed near Union Square, New York City *Mississippi, 1930s*

the Depression, it was the same Depression we were feeling here in Mississippi but evident in such another way in the city: lines of people waiting for food and people selling apples and sitting there in Union Square, all reading the daily paper's want ads. It was a different homelessness too from what we see today in New York. These people of the Great Depression kept alive on the determination to get back to work and to make a living again. I photographed them in Union Square and in subways and sleeping in subway stations and huddling together to keep warm, and I felt, then, sort of placed in the editorial position as I took their pictures. Recording the mass of them did constitute a plea on their behalf to the public, their existing plight being so evident in the mass.

Do you think someone, an outsider, for instance, who sees the collection of your black photographs together makes editorial comments?

They might. They might or might not know that poverty in Mississippi, white and black, really didn't have too much to do with the Depression. It was ongoing. Mississippi was long since poor, long devastated. I took the pictures of our poverty because that was reality, and I was recording it. The photographs speak for themselves. The same thing is true of my stories; I didn't announce my view editorially. I tried to *show* it.

"Unsheathed reality."

It was unsheathed. And when it was published, *One Time, One Place* constituted a statement of that reality. It wasn't needed for me to say, "Look what a bad thing."

Or, "Look how these people are facing it, facing up to it, meeting it, hoping as well as enduring it."

Will you tell of a proposed book called Black Saturday?

It was essentially the same as what later became *One Time, One Place,* plus a number of my short stories. I was trying to interest a publisher in my stories through the combination. I got a composition ring book and pasted little contact prints in what I fitted up as a sequence to make a kind of story in itself. I used the subject of Saturday because it allowed the most variety possible to show a day among black and white people, what they would be doing, the work and the visit to town and the home and so on. I submitted along with the pictures a set of stories I had written, unrelated specifically to the photos,

except that all were the South, and tried to interest book publishers in the combination.

And what was the reaction?

Rejection. It was an amateurish idea.

Did they give a reason?

Well, there were obvious ones to such a combination as I was offering. They said they were sorry. (Most of the letters are in the Archives [Mississippi Department of Archives and History].) They were understanding and kind, but it was a fact that such a book was unpublishable. They were sympathetic to the stories, but weren't much interested in the photographs – they were not that kind of editors, that was not their department.

Were any of the stories later published?

They were all published. First in magazines, then in *A Curtain of Green* and *The Wide Net,* five or six years later.

And most of the photographs were later published in One Time, One Place.

Yes. I'd like to point out that when a publisher *did* bring out the book of photographs, thirty years later, it was a literary editor who did it, and saw it through: Albert Erskine, of Random House. He was editor of my last two novels at Random House.

And you didn't publish a story until 1936?

1936 is right. That was the first story I submitted to a magazine, "Death of a Traveling Salesman." A so-called "little magazine" accepted it, called *Manuscript,* published in Athens, Ohio.

It seemed that your taking photographs stopped or seemed considerably slowed down as you began publishing stories. The collection of photographs in the Archives indicates that by about the mid-1940s you had set aside your camera. What happened?

I guess I was still taking pictures. They were for my own pleasure, of my family and friends. The new jobs I had all had to do with journalism, not pictures. And fiction writing was my real work all along. That never let up.

I think the latest photos were in the 1950s.

That's when I lost my camera.

Will you tell about that?

I was on my first trip to Europe, and I carried my Rolleiflex and took pictures all the way through. As I was getting ready to go home, it was May Day and I was in Paris, and I had friends there and had spent the day with them in Meudon, near Versailles I think that is. It was the home of the Mians. He was a sculptor, Aristide Mian. His wife was the American writer Mary Mian. They had three growing daughters. All were on hand, and all kinds of people they knew. So I

took pictures of everybody and everything. A record of happiness. Then I left on the train, got off at Gare Montparnasse to take the Metro to my hotel off Boulevard St. Germaine. They'd given me a bunch of lilacs, party food, presents, everything, saying goodbye, and I sat down on the bench in the station holding it all, with my camera beside me. And got up without the camera. I missed it as soon as I got on the subway and took the first train back. Of course it was gone. I never saw it again. Of course what I grieved for most was that that roll of film was still in it, the pictures that I had taken. If I could have just got that back, the May Day party, I would have almost given them the camera.

And those people would never be assembled that way again.

Never assembled. Never again.

So that slowed you down in your picture-taking.

I punished myself. I didn't deserve a camera after that. I was so crushed, and by then cameras were much more expensive and of course now they are out of sight.

When the team of Farm Security Administration photographers came on their individual trips through Mississippi, you too were working for a federal agency, the WPA. Did you chance to see Walker Evans or any of them or their work?

Oh, no. What I should have said a while ago is that the difference between my pictures and Walker Evans', among other differences – those people were professionals – is I never posed anybody – that was on principle – and his are all deliberately composed pictures. I let my subjects go on with what they were doing and, by framing or cutting and by selection, found what composition rose from that. So, I think that's a quality that makes them different from those of professionals who were purposefully photographing for an agency, or a cause.

Some of your pictures show people at a sideshow at a carnival. What drew you to photographing oddities like carnival people?

Oh, I love crowds to take pictures in. I photographed everybody. I always did love the fair and circuses. Once or twice to photograph them, I got up early before daylight and went down to see them arrive, watch them set up the tents and the rides down at the fairgrounds. And I remember once happening to eat breakfast with some of the carnival people in the bus station. *That* was getting close to life!

Some of the people are freaks. Are you familiar with the photographs of Diane Arbus?

Yes, somewhat.

How do you react to photographs of freaks, the kind in her work?

I think that it totally violates human privacy, and by intention. My tak-

ing the freak *posters* – not the human beings – was because they were a whole school of naive folk art. And, of course, totally unrelated to what you saw inside the tent. The posters show bystanders being suddenly horrified at a man who could twist himself like a snake. They are all looking with hands drawn back and shrieking, and *they* were all perfectly dressed, probably wearing evening clothes.

Did your story about Little Lee Roy, "Keela, the Outcast Indian Maiden," rise out of your experiences in viewing carnival people?

Actually, it grew out of my job with the WPA. In the publicity department, one of the chores we did was set up a booth for the WPA in county fairs. While I was doing the job, I didn't ever see the midways or shows. Someone told me about something like "Keela, the Outcast Indian Maiden," which I'd never heard of. Of course, I know now it's a geek, and an act that's very prevalent. Nothing in this world would have induced me to go and look at the show. It's a psychological story I wrote in "Keela." I was interested in what sort of points of view people could have toward such an atrocious thing, including that of the victim himself. He, I guessed, like people in many a kind of experience, might have rather enjoyed it years later in his looking back on the days of excitement. You know, things, awful as well as not, get to be kind of interesting in a different way after you've

lived through them and they are embedded in your past. Lee Roy had eventually forgotten all the humiliation and the horror.

But all of his children are there.

All of his children are there, and *they* don't want to hear about it. They just say, "Hush, Pappy!"

Could we speak of some of the notable photographers who have taken pictures of writers? You have been in photographs by Jill Krementz, Kay Bell, Thomas Victor, Jerry Bauer, Rollie McKenna, William Eggleston, and others. Do you mind being photographed?

Yes, it's not my nature to be on the other side of the camera. It came about through the circumstance of my being a writer. Many of my stories were in *Harper's Bazaar* and it was through the editors' wish that I was a subject for Cecil Beaton and Louise Dahl-Wolfe, and Irving Penn.

Will you tell about being photographed by Cecil Beaton?

He's the one I was most scared of because I was the most familiar with his work, over the years of seeing it in *Vanity Fair.* I had to go to his apartment in one of the hotels up Fifth Avenue. I didn't know what to wear. I thought I wore the safest thing, "a little black dress." And went up in the elevator and he met me at the door. It seemed to me he was the most shy and reticent and kind person I'd ever seen. And he held a Rolleiflex.

It looked just like the one I had lost. And it was hand-held, and he had no lights anywhere. And it was in the winter time, a grey cold day, but he had a great flowering mimosa in the window. Not *our* mimosa trees, but the South-of-France kind, with little powdery yellow flowers all over it, so it looked very tropical in the window. It was fragrant. My black dress of course *was* wrong. But he gave me a wicker armchair to stand behind. It looked very "Cecil Beatonish." Everything was very decorative and summery. And I don't remember anything he said except just kindnesses. He offered me some tea or something, and everything was very muted and peaceful. He took the pictures, and we parted. It was like a social visit in a way, but there was not much conversation back and forth.

He stood you over by the window, didn't he?

I've got one of the prints. He sent me one and had autographed it, which I thought was extremely sweet of him.

Will you tell about the photographic session with Louise Dahl-Wolfe, who was a Harper's Bazaar *photographer? A fashion photographer.*

She was interesting. I enjoyed it.

In the photographs of you, it looks as though you are against a rock on the beach.

It's in Central Park. I was to lie back on a rock in Central Park. I

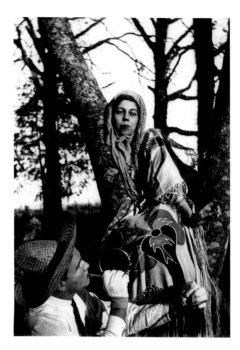

had on a tweed suit and a sweater. The session was brisk and very lively, and she was an interesting woman. It was Irving Penn who took me to Central Park too, and we made some funny photographs along with the ones he used.

What kind of funny photographs did he take?

In one of them I was kneeling on the ground by a sign that read "To restrooms and bear den." And one of them was sitting up in a tree, sort of like the one Frank Lyell and I concocted with myself perched in a tree at Annandale while wearing a Spanish shawl, and Frank serenading me from below.

You as a photographer yourself observed how these photographers worked. What specifically did you

note about their attitudes and techniques? Anything?

I doubt that I was able. I think I observed rightly that Irving Penn was at an early part of his career. He was venturesome. Whereas, Louise Dahl-Wolfe and Cecil Beaton were majestic figures, whose work everybody knew. What I noticed about all of them was how none of them gave you any directions, laid down any rules. I don't know whether because I was hopeless or whether they just didn't ever do it; they didn't say, "Stand here," and "Put your hand here." They *never* said, "Smile, please!"

In "Why I Live at the P.O." the narrator tells that the only "eligible" man ever to appear in the town was a photographer who was taking "pose-yourself photos." Could you tell what a "pose-yourself photo" is?

A man that came through little towns and set up a make-shift studio in somebody's parlor and let it be known that he would be taking pictures all day in this place, and a stream of people came. He had backdrops – sepia trees and a stool – then let them pose themselves. That was an itinerant livelihood during the Depression. Itinerants were welcome, bringing excitement like that, when towns were remote and nobody ever went anywhere.

Some of those funny photographs that you and Frank Lyell took are set up like the "tableaux vivants" Julia Margaret Cameron photo-

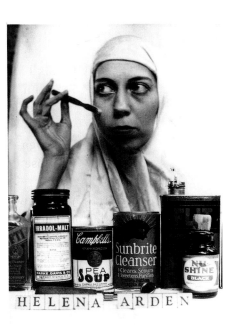

HELENA ARDEN

graphed, costume pieces. Hers were a kind of "pose-yourself" photography.

Oh, they were high-minded. I think they belonged to the Rossetti period, taking themselves seriously as art.

You and your friends created some "tableaux vivants." Will you tell about those?

Well, as I say, during the Depression we made our own entertainment and one of our entertainments was to take funny pictures. We dressed up a lot, something to do at night. Even when we had little dinner parties for each other with four or six people, we wore long dresses. And everybody came, you know, we came *as* somebody, like parties in *Vanity Fair,* people like Lady Abdy, and the Lunts, all the

people that Cecil Beaton photographed doing things at parties. We were doing our version of that. We didn't take ourselves seriously. We played charades, word games.

There is one photo of you satirizing Elizabeth Arden and Helena Rubinstein, "Helena Arden," showing you draped in a sheet and applying some very strange cosmetics.

That's right, out of the kitchen. Bon Ami.

Was the photography here a parody of "smartness" in the Mencken sense?

No, we were satirizing the advertising game. In the thirties you could laugh at advertising. It was all fun. A lot of it came out of our admiration of the smart world, our longing for the artistic scene we were keeping up with: the theatre, art, and music. We'd all been to New York! The year before, at Columbia.

Didn't you yourself do some freelance fashion photography?

I tried to earn a little money doing that. I took one picture every Sunday for a shop called Oppenheimer's. And the Emporium later. I got my friends and my brother's girlfriends to pose.

In their fashions?

The shops' selections. I would pose them in different places the way they did in *Vanity Fair* – in front of the New Capitol, around the town like that. They were not very good.

And there are some time exposures in which you and a friend are set up as women of fashion.

Right. Helen Lotterhos, Margaret Harmon, and Anne Long. With jars of pampas grass, and rising cigarette smoke. Subtle lighting. These were all fun, you see. And nothing cost anything. We had jobs, most of us, by day, and thought up our own entertainments in the evening. We'd just come out of college. We were young. We had a good time in the Depression.

What do you recall about photographing Katherine Anne Porter?

I did it every minute. A summer at Yaddo. I went to Yaddo, I'm sure, at her instigation, which you know is in Saratoga Springs, New York. A retreat for artists. She had been there a number of times as a resident. I was reading proofs of my first book. Katherine Anne was supposed to be writing the preface to my book. And my editor used to write me and say jokingly, you're supposed to make her do it. Which, of course, I never mentioned! She was busy writing what was then called *No Safe Harbor.* It was eventually *Ship of Fools.* She had also bought an old run-down clapboard farmhouse, perfectly beautiful, sitting in a meadow outside Saratoga Springs. It was heavenly, in the real country, and she was restoring it. We went out there every day. She bought a car, a Buick, first time she had ever had one, and had just

learned to drive. I helped her drive some of the time, if I remember. I would rather help her drive. Anyway, we went forth. So, of course, I took pictures of all the progress of the house and of the daily life of Katherine Anne. All the good pictures I took of her in my life were out there. She found in the walls of this house honey bees' nests that must have been there since it was empty, and she found a whole lot of tiny ladies' slippers and men's shoes from, she thought, Colonial times. And some hoops to be worn with hoop skirts. I was at Yaddo for six weeks or something like that. Katherine Anne and I were already friends, but we became very good friends then. Katherine Anne was a cook. She made French onion soup, an all-day process. I was the grocery girl. I couldn't work in Yaddo. Everybody had a sign on their door saying, "Silence, writer at work." I read my proofs, but I couldn't write in there. Everything was so tense, even exalted. So I walked into Saratoga, and to the races, and took pictures in Saratoga. And I would bring home groceries for Katherine Anne to cook with, and so we had a good time.

Will you comment upon this wonderful photograph of Katherine Anne Porter?

Yes, I was pleased with it because I thought it showed something of her inner spirit, which she didn't usually show in her photographs as a beauty or a performing artist, reading for the public on stage.

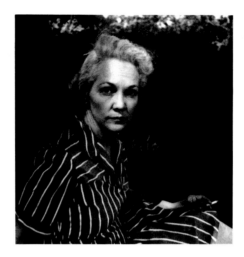

Katherine Anne Porter at Yaddo

Of course, those are all radiantly beautiful. But this quiet, unposed one was the inside story; the awareness of the writer I think came through. Its regard is introspective, deeply serious. And I think it's more beautiful. I don't know what she thought of this. I don't know what she thought of any of them. But this one has held up for me, all these years, as a sobering glimpse of this artist's inner life.

Henry Miller was not a friend of yours, but he showed up in Jackson and you and some of your friends took him to see the ruins of Windsor. Is that right? And you took some photographs?

It's a long, stupid story, I think.

Please tell the long and stupid story.

He was not a friend or an acquaintance. He had just come back to America from being an expatriate all these years. And Doubleday, his publisher, thought it would be a wonderful idea for Henry Miller to go all over the country, which he had not seen in, lo, these many years and write his impressions of America. They were going to buy him a glass automobile, so that he could see everything and, in turn, be seen everywhere. He was to write a book to be called *The Air-Conditioned Nightmare.* So, John Woodburn, my beloved editor, who was a big tease, thought, "O.K., I'm going to route Henry Miller by Mississippi to see Eudora." With a big laugh. Well, my mother said, "Indeed, he won't enter my house." He was the only person in her life she ever said that about. She was quite firm. But he was going to be here three days. I didn't know exactly what we had that he wanted to see. I did my best, and showed him everything.

I got Hubert Creekmore and Nash Burger, and from time to time a third friend, also a male, to be with us as we drove about in the family car. I took him all around. He was infinitely bored with everything. Nash, who knew a lot about the local history, tried to tell him something about the country we were passing through. He didn't even look out. He wore his hat all day. Hubert knew all of Henry Miller's works, but Henry Miller didn't want to start on that. Windsor was one of the places we took him to, and Natchez, and the Mississippi River, and the lost town of Rodney – and Vicksburg. And every night we took him to the Rotisserie

to eat. If you couldn't have people to dinner at home, as was our case, there was only this one good restaurant to take people to. Sometimes we went to the drive-in part, sometimes to the steak part, sometimes upstairs to the dance part with the band – it was ramshackle. And finally, Henry Miller said, "How does a town like Jackson, Mississippi, rate three good restaurants!"

Well, you had a good story for John Woodburn, didn't you!

Oh, John was crazy about Henry's visit. And, of course we were safe – Henry Miller didn't mention the existence of Jackson in *The Air-Conditioned Nightmare*. And as for the glass automobile – not a sign of that. We had to ride him in the Welty Chevrolet or he couldn't have budged at all.

So much of your writing is set in Mississippi, and you have said that it is from place that much of your fiction arises. Do you see that the photographs you took outside your native state of Mississippi – in Ireland, Wales, Nice, Mexico – show the imprint of place also?

I suppose that what made me take the pictures was some irresistible notion that I might capture some essence of the place I'd just arrived at, new to me and my eyes and my camera. Yes, I was smitten by the *identity* of place wherever I was, from Mississippi on – I still am. Incidentally, the reason I was in England at the time of the Monk's House picture was to give a paper

to a meeting of British teachers of American subjects, and I took for my title "Place in Fiction."

You were a guest of Elizabeth Bowen at Bowen's Court in Ireland. Will you tell about that and about photographs you took there?

Elizabeth Bowen, V. S. Pritchett, Mary Lavin, Katherine Anne Porter – all of them became in time my good friends, and what first drew us together in every case, I believe, was the affinity – the particular affinity – that exists between writers of the short story. Elizabeth Bowen and I had known each other's work for a long time, and we met when I went to Ireland and she invited me to Bowen's Court in County Cork. These pictures came of my first visit to her in the early spring of 1950 and from a summer visit a year or so later. I'll add that Elizabeth Bowen responded to place herself with the greatest sensitivity, and did so when she came in turn to visit me in Mississippi.

How did you happen to take a picture of Virginia Woolf's house?

English friends who knew of my veneration for the work of Virginia Woolf drove me to Rodmell to see Monk's House. We stood there, our backs to the River Ouse, and before us the flower-covered house, the windows of the room in which she had written during the last years of her life.

Among your photographs are some

remarkable portraits. Will you recall the occasions when you photographed the composer and conductor Lehman Engel?

In a little woods behind our back garden, my two younger brothers Edward and Walter put up what they called "the Hut" – scrap lumber, with hammer and saw. It was a little boys' neighborhood club, with passwords and all. I wasn't allowed in, but after they outgrew it, I turned it into what my friends and I called "the Pent-House." It was the Hut with its walls pasted over with photos out of *Vanity Fair* – our favorite performers in the New York theatre – Noel Coward, the Lunts, the Astaires. We had our parties there. It was where I took photographs of my friends. Lehman Engel visited home from New York every summer.

And you met several artists at Yaddo in 1940. The sculptor José de Creeft, the etcher Karnig Nalbandian, and the composer Colin McPhee. You took photographs of them.

Yaddo was full of artists, and the summer was long enough to get to know one another. Karnig Nalbandian and Colin McPhee were installed in the same farmhouse where Katherine Anne Porter and I were, so we had a little neighborhood of our own. In our respective backgrounds were – well! Karnig's family is Armenian, Colin's music had originated in Bali, Katherine Anne was writing her novel then,

and she allowed me to read its beginning – in Mexico. I was on the receiving end of it all. De Creeft was the great Spanish sculptor. I came to know him and his work that summer and our friendship lasted from then on. He allowed me once to write a requested article about his work – I was the only writer he knew, so he named me! I did my best.

One of the most recent photos you took shows V. S. Pritchett in Savannah.

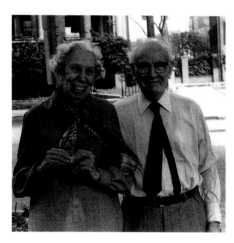

Eudora Welty and V. S. Pritchett, Savannah, Ga., 1985

Victor and Dorothy Pritchett and I are friends who seize the day, the time and the place, where we can next meet again and continue our conversation. We've arranged it in New York, in London, in Nashville, and this time in Savannah. None of us had ever visited Savannah before, and we spent a weekend in a cottage with a garden, a delightful place to talk, with that wonderful city to walk in. This time, the camera was along to commemorate the reunion.

Black-and-white and color photography. Which do you prefer?

Well, black-and-white is the only kind I know anything about, but I really do prefer it anyway. I haven't anything against color photography, but I love black-and-white. Just like black-and-white movies. I hate the idea of tinting the old ones.

William Eggleston is a photographer whose work is in color. What do you find most significant about it?

You mean about the color of it?

About his work. Not necessarily the color, but what do you find especially important?

The photographs that make up his book *The Democratic Forest* are presented as a record of the world we have made, of what our present civilization is. And he uses his color very effectively, purposefully. The urban world is such a raucous thing, the color is used to express that. And in contrast he uses color very tenderly in showing the frailty, the vulnerability of what has survived the onrush of urbanization. I don't know what Bill Eggleston would say to that. That's what I see.

You have an interest in signs and billboards, especially the unintentionally ludicrous ones.

Oh, yes, I love those.

And sometimes photographed these. Do you have any recollections of some special ones?

There's the Tiger Rag Gas Station. The Old Miss. Slaughter Pen. There's one sign I saw just recently on the way to Ole Miss, in a town as we passed through, Kosciusko. There was a vacant lot grown up in weeds and a wooden sign on it, very low to the ground saying "Jesus Christ is Lord in Kosciusko." Apparently

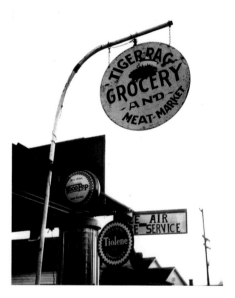

it's the site of a church that's yet to rise there on the vacant lot. Behind it already is a motel, no connection, I guess, saying "Economy Motel." All signs reveal us.

When you photographed some of the poor people during the Depression, did you feel any responsibility in taking their photographs?

It didn't seem to me I was doing anyone any harm. I wanted to show the life in front of me. I wouldn't have taken a mocking picture; I wasn't taking it to exploit them. I was taking it to reveal them, the situation in which I found them. Some of the people I took said they had never had a picture of themselves in their lives and they wanted me to take it and in that case I tried to get one to them.

When you snapped the shutter, what was the right instant?

You didn't know it until you did it. Or I didn't. And of course, all around every right instant, I've taken others that weren't. I don't mean I took twenty-five shots of one thing like people do with cameras now. I usually just took a few. You shouldn't surround people, you shouldn't dance around people, I think. I didn't put them through any of that.

Retrace your steps when you were traveling as a publicity agent for the WPA. Where did you go and where did you stay and were you traveling alone? What was one of the trips like? Where did you eat?

There was more variety than pattern. It depended on where I was to be sent that day. In Jackson we had an office up in the Tower Building of five people. I worked directly under another publicity agent who knew a lot more than I did. He was a professional newsman, named Louis Johnson. He's dead now. He was senior publicity

agent. I was junior publicity agent – which also indicated I was a *girl*. We sometimes traveled together, and he did the news work and I did feature stories, interviews, and took some pictures.

What you would do depended on the project. If it were a juvenile court being set up, you would interview the judge on it. We visited a project for the blind of teaching people braille. We'd visit the construction of a farm-to-market road. Mississippi had so few roads then and very little was paved. There were a lot of people who couldn't get to town, farmers who were mired down in bad weather. The WPA went about putting in roads – they'd be tarred sometimes or graveled. We interviewed people living along the road, and the road workers, about the difference it made in their lives. If there was a new air field opening where planes could take off and land, just created out of a farmer's field, we would go and see that. They weren't *airports*. They were just landing fields. I think Meridian and Jackson were the only places that had better than that. I was sent to Meridian with my camera to interview the Key brothers. They had a national reputation of staying up for very long periods of time, testing planes. I'd never been up in an airplane, and I was terrified that I was going to have to do it with the Key brothers. At that time you just leaned out of an airplane and took pictures of the ground below. You sat behind the pilot, with the wind

blowing. There was just one passenger seat. But I escaped without being invited. When the tornado devastated Tupelo, the WPA tried to help, and I went up there and photographed Tupelo the day after it'd been struck and nearly demolished. You could expect anything in the way of work.

Did you travel by bus or car?

I mostly went by bus. If it was just going and coming on the same day, I used the family car. I couldn't use it always, since I had brothers in school and my mother needed it.

Did you stay in hotels?

Stayed in hotels. The hotel in my story "The Hitchhiker" was a perfect portrait of some of the hotels I stayed in. Not particular ones, sort of an amalgamation. The good ones had electric fans in summer. That was the only way you could cool off, before air conditioning. No telephone in the room. You had to go to a landing or downstairs to the desk. Very nice people ran them, and kind people.

When you were taking photographs were there ever any angry reactions?

No, I don't remember any. I don't know why there would have been. I remember in Utica photographing the black bootlegger who said, "I'm gone kill you," which was her joke.

With an ice pick.

She had an ice pick. She didn't mean it. She was teasing, like "I'm gonna get you."

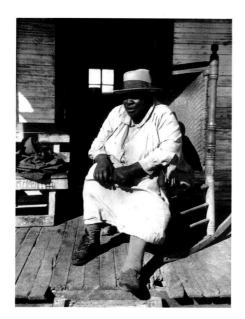

At the bootlegger's house

You were a young, white, southern woman in black neighborhoods. How were you received when you went to the black districts?

Politely. And I was polite, too. It was before self-consciousness had come into the relationship or suspicion. That's why I say it couldn't be repeated today, anywhere.

Were they curious about you and why you were there?

Perhaps casually. There was usually something to talk about that we both knew, about either what they were doing or about the place. I would say, "I grew up near where you are living now" or ask a question. There were connections.

How did you entice them sometimes to let you take their photograph?

I didn't "entice." My pictures were made in sympathy, not exploitation. If I had felt that way, I would not have taken the pictures. If you are interested in what viewers of these pictures do say about them, I can give you some idea in what they say to me. There's an exhibition of my photographs (mostly black subjects) that the Mississippi Department of Archives and History has been sending for a number of years around the country on requests from galleries and schools. From the letters viewers write to me, I think the photographs are seen as honest and recognizably sympathetic. I have never heard from a hostile viewer, of either race, of North or South. When I was invited to be present at a showing of my photographs at the Museum of Modern Art in New York, and to give a commentary on each one as it was shown at a slide lecture, I found the audience receptive and openly interested. I recall among those who came up to speak to me afterward a number of blacks, from the North and the South both, who wanted me to know they regarded my photographs as truthful and understanding. I get many letters from people who say they are touched very much by *One Time, One Place.*

Have you any idea of what ever happened to some of the anonymous people whose photographs you took?

I hear from people who recognize themselves or family members.

Some of them write and tell me. I don't think of them, of any people, as "anonymous."

In the case of the black people who had the Pageant of Birds down on Farish Street – we got to be further acquainted because of Maude Thompson, who invited me to take the pictures. This came about when walking along Farish Street in Jackson I saw these girls with big paper wings, carrying them over their arms along the street. I asked about them, and they said they were

Maude Thompson, director of the Pageant of Birds

going to have a bird pageant at their church, Farish Street Baptist, and would be glad for me to

attend. And when I did, of course I wouldn't have taken a camera into the place. I wouldn't have misused my invitation by disrupting the program by taking a picture. Even so, they made us sit on the front row, which already called attention to us. It was a marvelous pageant, original and dramatic. Then Maude Thompson asked me if I would come back and take some pictures of it. She got the birds to come back, and she posed them. She posed herself, and told me how she wrote and directed the pageant, and so we got to be friends. I think I said in *One Time, One Place* I used to run into her in railroad stations. She was a big church worker, and she would go to funerals out of town and maybe do other churchly things, and we always greeted each other and had conversation about the continuing bird pageant.

How did you discover Ida M'Toy as a subject for photographing?

Taking her picture was an afterthought. She was a secondhand clothes dealer who had a store in her house in the Depression. White customers would bring her their last year's clothes that she wanted to sell to her black customers, taking her commission out of the sale. She was a Jackson institution. She considered that she did a good deed to both white and black, and not for the first time: she had had an earlier career as a midwife. The combination is why I thought she was so fascinating. One of the pic-

tures you have is "Born in This Hand." At the name of any well-known citizen she'd make this gesture, and intone: "Born in this

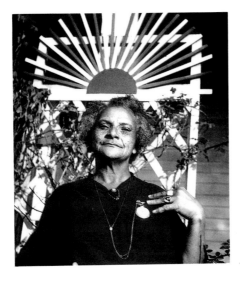

Ida M'Toy, midwife, displaying "Mama's Brooch"

hand." Children were all born at home in those days, and she served white and black, of course. She was a young nurse, too, in the days of yellow fever. She said she remembered when there was a rope stretched across Jackson, and if you had yellow fever, you couldn't cross that rope and go into the other part. And she said, "I nursed them six at a blow." She was part of the history of the town.

What ever happened to Ida M'Toy?

Until she died, in the sixties, I went to call on her time after time. We were old friends. Her granddaughter, now 44 years old and a nurse, is coming to see me soon at her

request — she's one of my readers. She has said she is proud of my pictures and the essay I wrote about her grandmother. Now we can talk about her together.

Wonder what ever happened to "Mr. John Paul's Boy" in Rodney.

He was there as long as I was going there. He showed me the church, and where the post office was, and he told me he asked every day but he'd never got a letter in his life. So I used to send him cards sometimes. Never fear, the whole of Rodney looked after him.

One of your most poignant photographs is "Woman of the 'Thirties." What ever happened to her?

I don't know. I think she lived on the road between here and Utica, where I used to go quite a bit, and where I took a lot of pictures. And I think I did see her a time or two after that. She has a very sensitive face, as you can see; she was well aware of her predicament in poverty, and had good reasons for hopelessness. Well, she *wasn't* hopeless. That was the point. She was courageous. She thought it was a hopeless situation, but she was tackling it.

Some of the persons that Dorothea Lange photographed and those that Walker Evans photographed in Alabama were found not too long ago and shown as they are today. Have you seen any reports of things like that?

No. It would seem to me that that was exploiting them. For a second time.

Some of the children whom Walker Evans photographed are resentful.

I don't blame them. I would be too. I'd find that a cause for resentment.

As you said, a lot of the people whose photographs you took had never been in a photograph.

They had so little, and a photograph meant something. And they really were delighted. It didn't matter that it showed them in their patched, torn clothes. They wanted the picture. They were delighted at the evidence of themselves here – a picture was something they could hold. I've had people write to me through the years and say, "I saw my grandfather in your picture of such and such, and could I have a copy of the picture?" When possible I have tried to do that.

Of all a writer's attributes, you have said in "Place in Fiction," place is one of the lesser angels – that feeling wears the crown. These photographs we've talked about convey great feeling. Was this deep feeling the feeling that made you take the pictures?

Why, I'm sure it was. Human feeling for human beings was a response to what I saw.

I think we're talking about passion in the real definition of the word.

I think we are too.

And the passion was there before you snapped the shutter, and you certainly can see it in the photograph.

Well, thank you. That is the finest thing that could be said in their retrospect.

Some believe that it is an artist's works that best express his or her biography. How do you think these pictures you've taken pertain to yours?

Not in any way, I hope, except indirectly. I wasn't trying to say anything about myself in the pictures of people. I was trying to say everything about *them*, and my taking them was the medium. The photographs are saying what I saw. I was just the instrument, whatever you want to call it.

They're a record not only of what you saw, but they're a record of your feelings.

Yes, but I didn't take them for that. If they do that, it's because I took them with the right feeling, I think, to show what was there and what it meant. I would have thought it was intruding for me to have included myself in what I was doing. Any more than I would in a story. The story has to stand alone.

Here's a hard question.

They're all hard. What?

This will be the last question. You've had a long career. All your work is of great intensity and has from the very first been regarded

as superlative. Looking back over the entire body of your artistic work – stories, novels, essays, and photographs – one is astonished by and is in great admiration of your range, your talent, your passion, and your compassion. But rising above all of these is your vision. What do you, that artist, discern as the vision Eudora Welty has expressed in this work?*

Well, I think it lies only in the work. It's not for me to say. I think it's what the work shows, comprises altogether. That was a very beautiful question, by the way, which I thank you for, for the form of it. But as in everything, I want the work to exist as the thing that answers every question about its doing. Not me saying what's in the work. In fact, I couldn't. Some time, if I have the time left to me I would like to do more, but of course you could never make it full enough. You know, of what is out there and in here.

That's a good answer, too.

Well, it's the truth. I tried to tell the truth.

This interview was conducted by Hunter Cole and Seetha Srinivasan of the University Press of Mississippi at Eudora Welty's home in Jackson in January 1989.

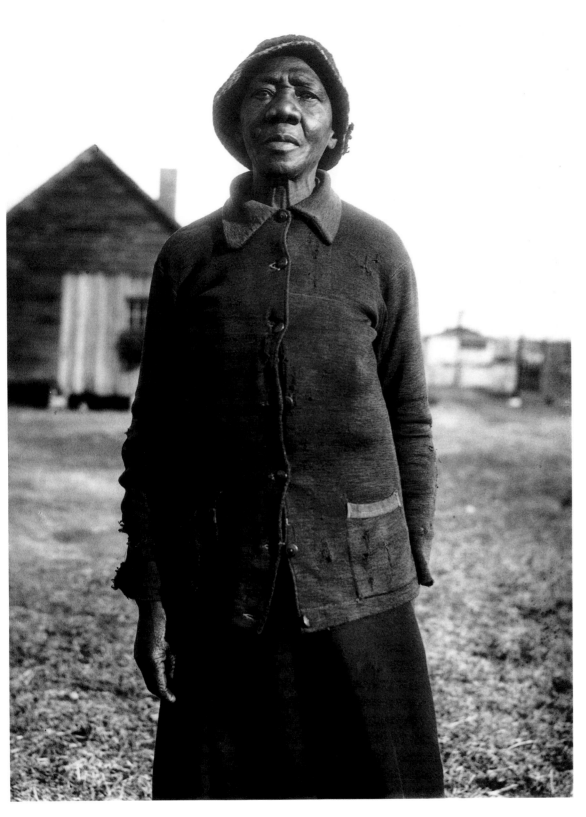

1.
A woman of
the 'thirties /
Hinds
County / 1935

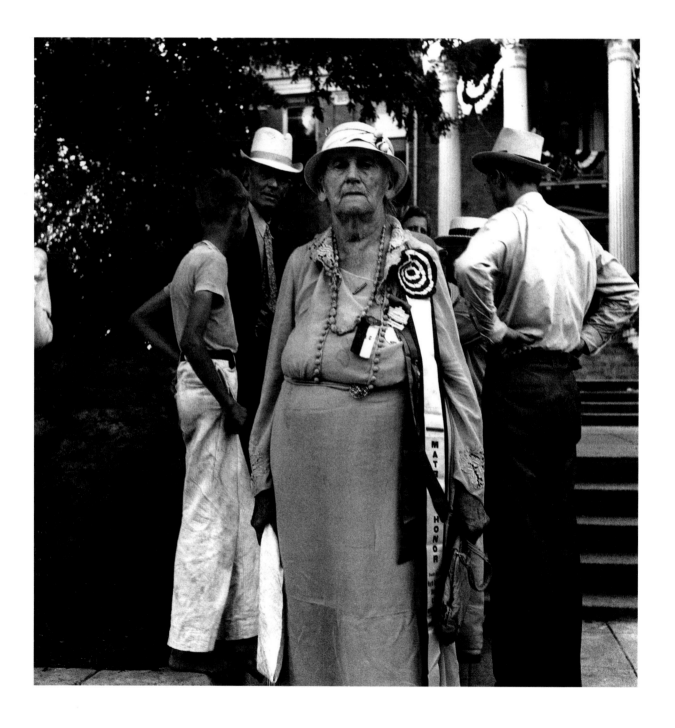

3. *Picking cotton / Hinds County / 1930s*

4. *Schoolteacher on Friday afternoon /*
Jackson / 1930s

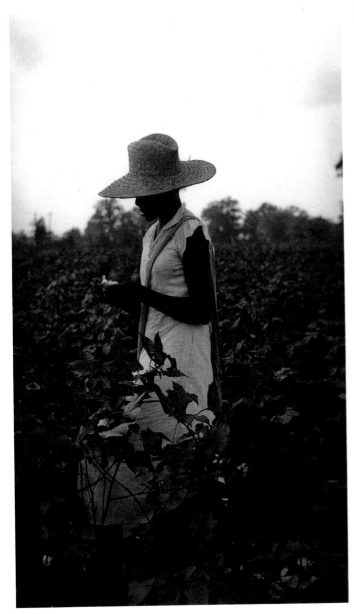

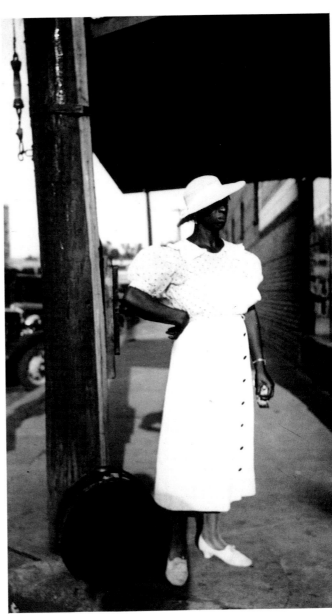

5. Ida M'Toy, midwife / "Mama's Brooch" / Jackson / 1940

6. "Born in This Hand" / Jackson / 1940

7. Nurse at home / Jackson / 1930s

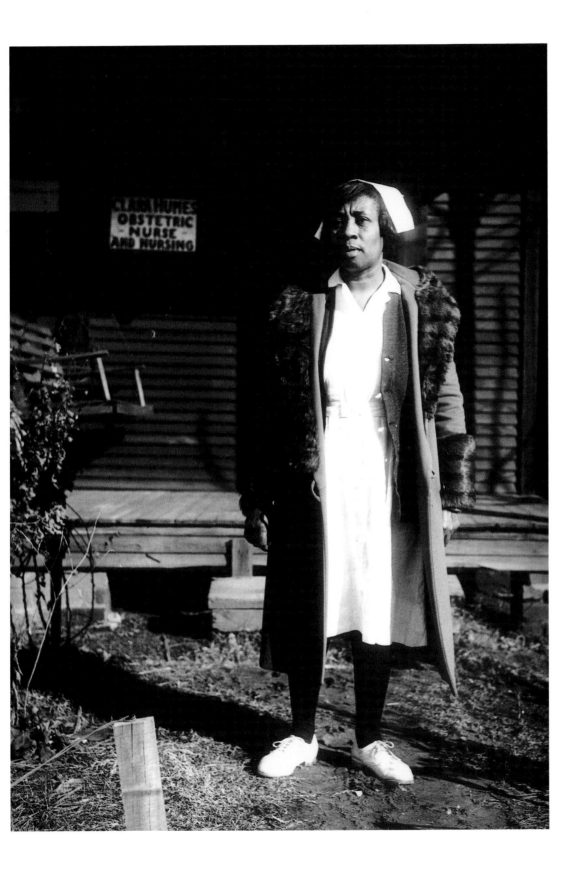

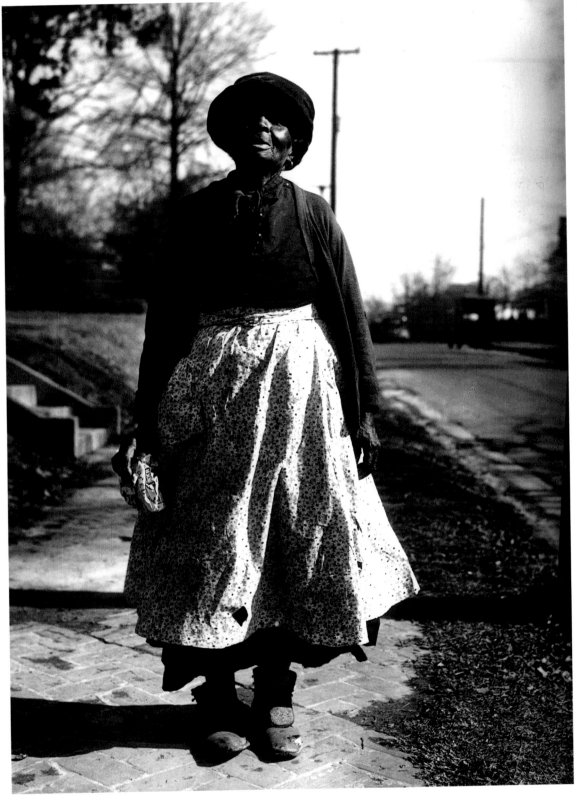

9. Day's end /
Jackson / 1930s

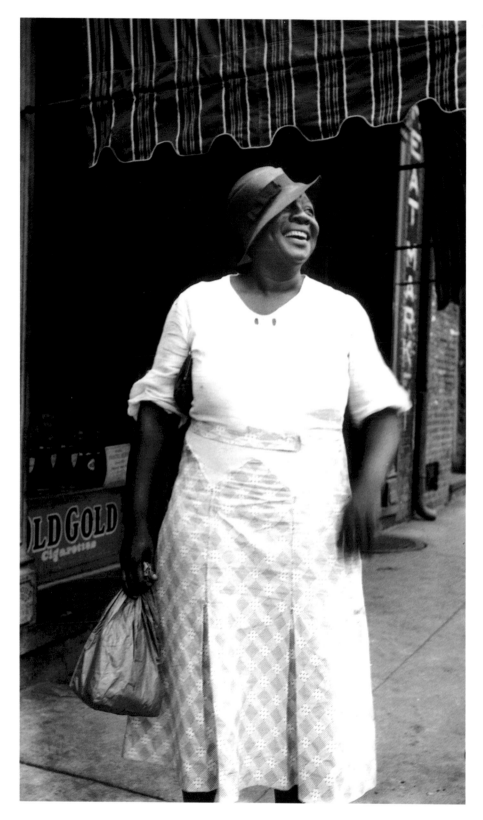

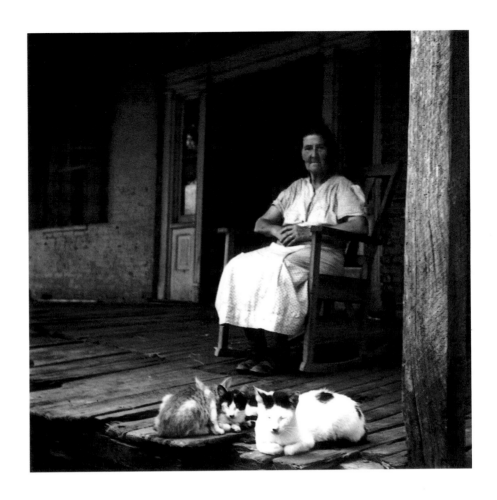

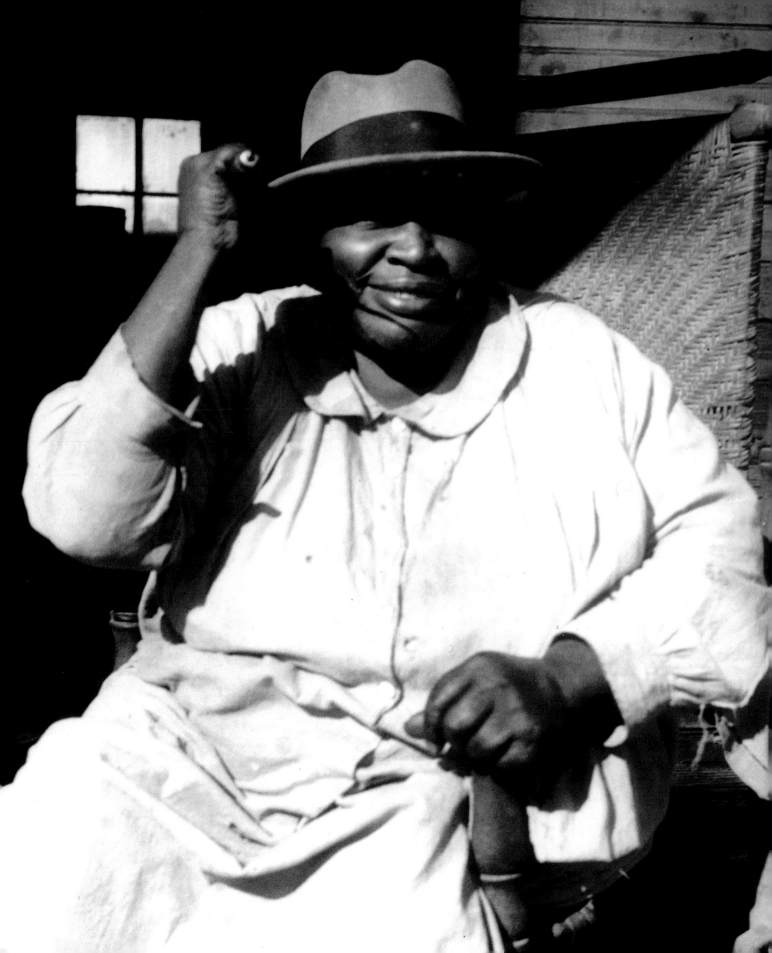

12. Woman with ice pick / Hinds County /

1930s

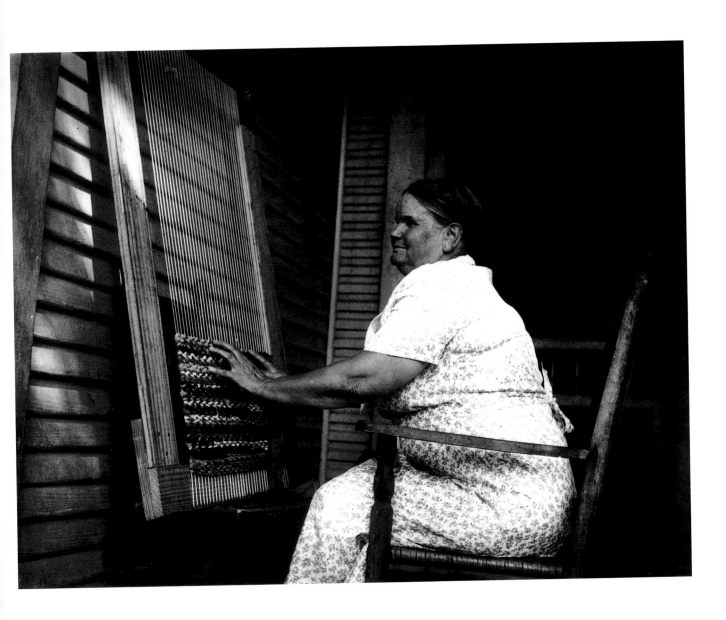

13. Blind weaver / Oktibbeha County /

1930s

14.
Hat, fan,
and quilts /
Jackson /
1930s

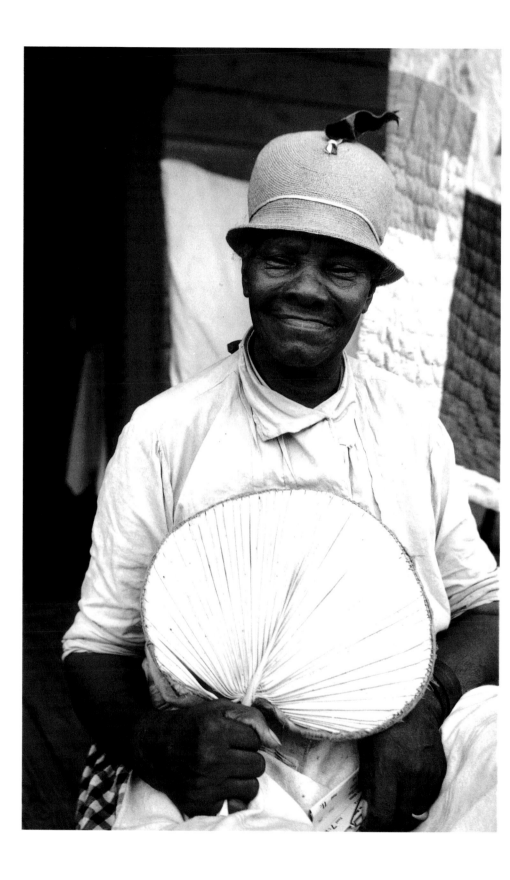

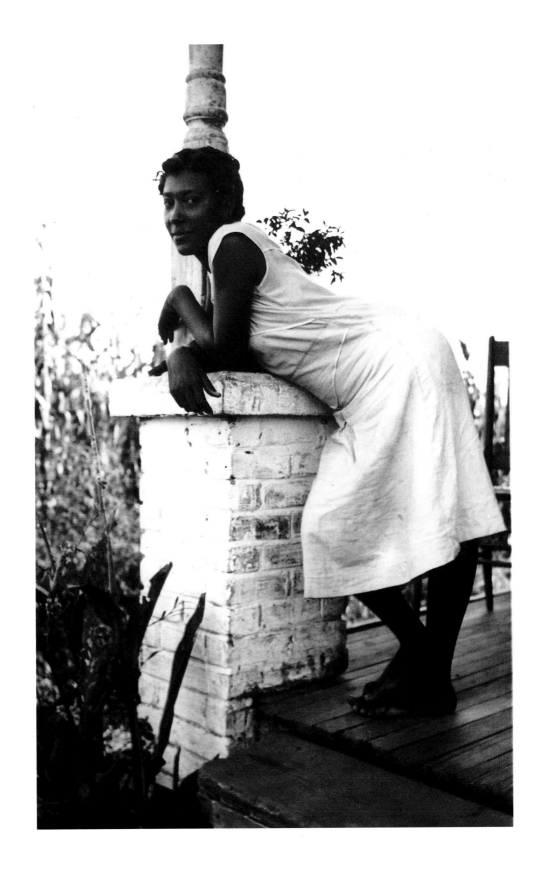

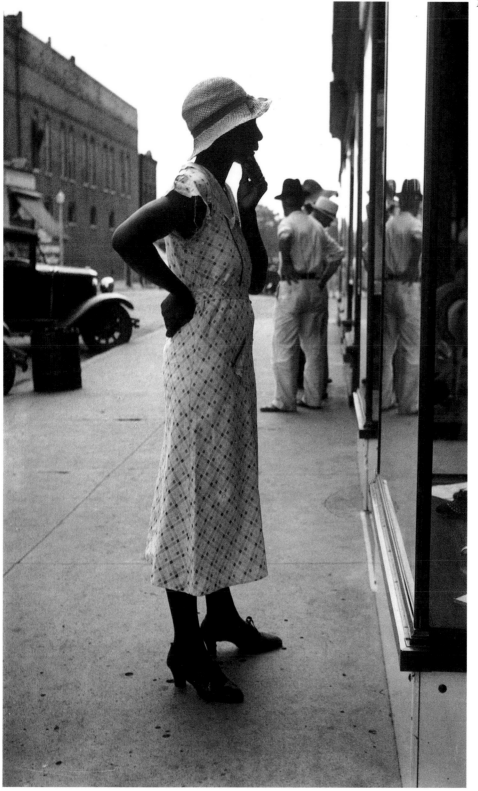

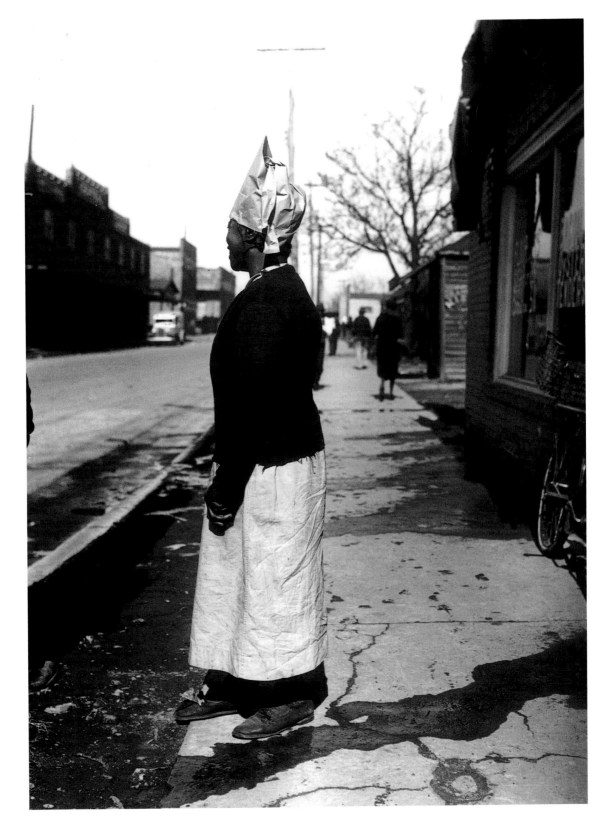

18. *The guinea pig / Jackson / 1930s*

19. *A drink of water / Jackson / 1930s*

20. *Chopping cotton in the field / Warren
County / 1935*

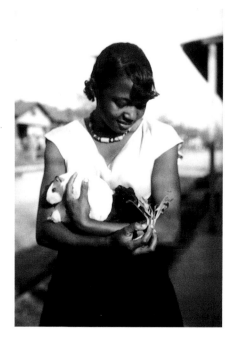

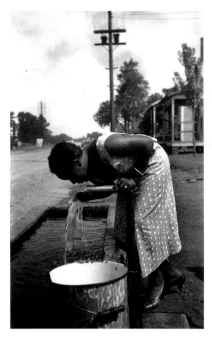

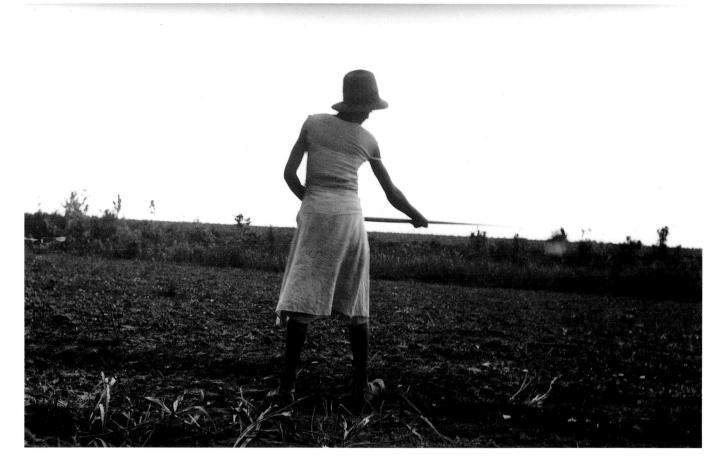

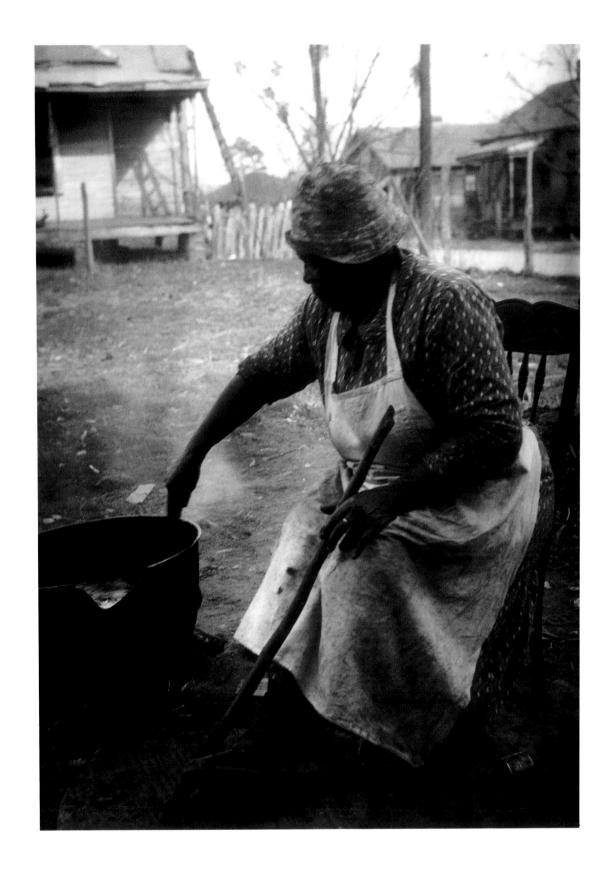

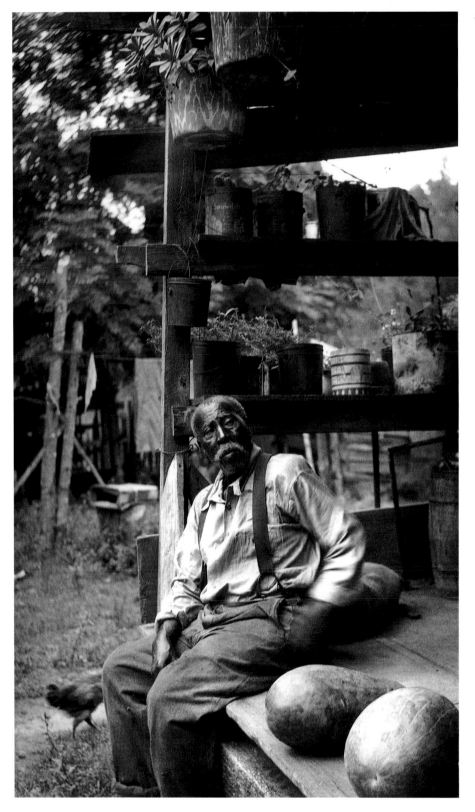

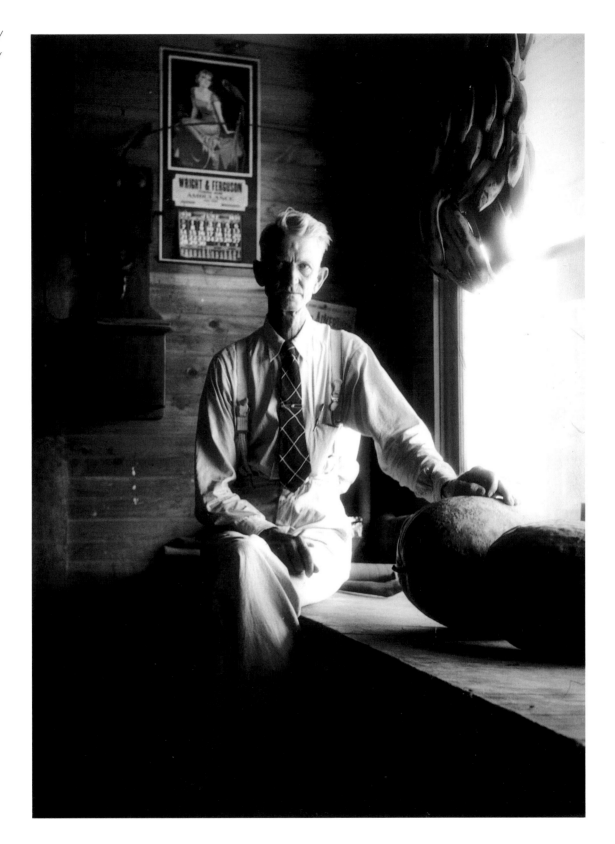

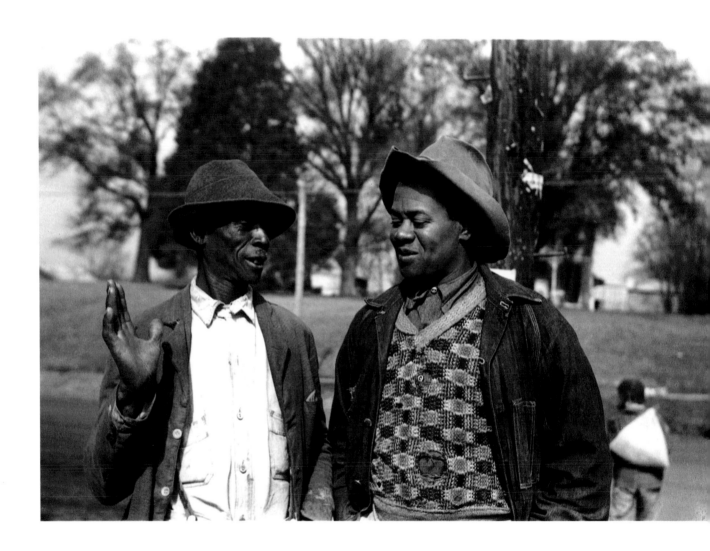

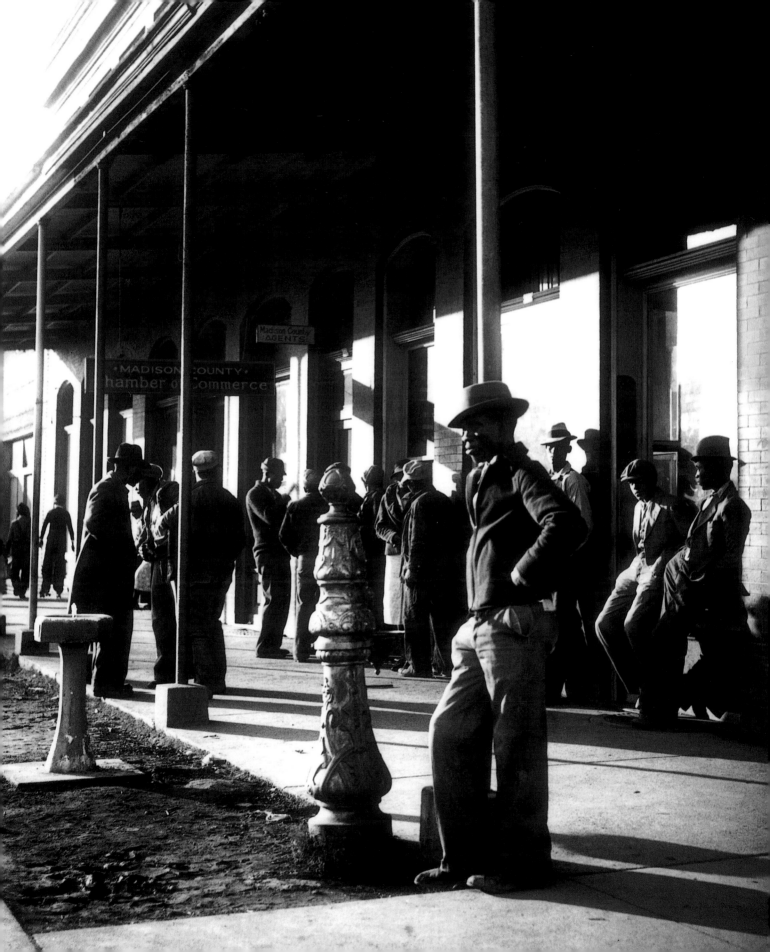

26.
Farmers in
town / Crystal
Springs /
1930s

27. *Village pet, "Mr. John Paul's Boy" / Rodney / 1930s*

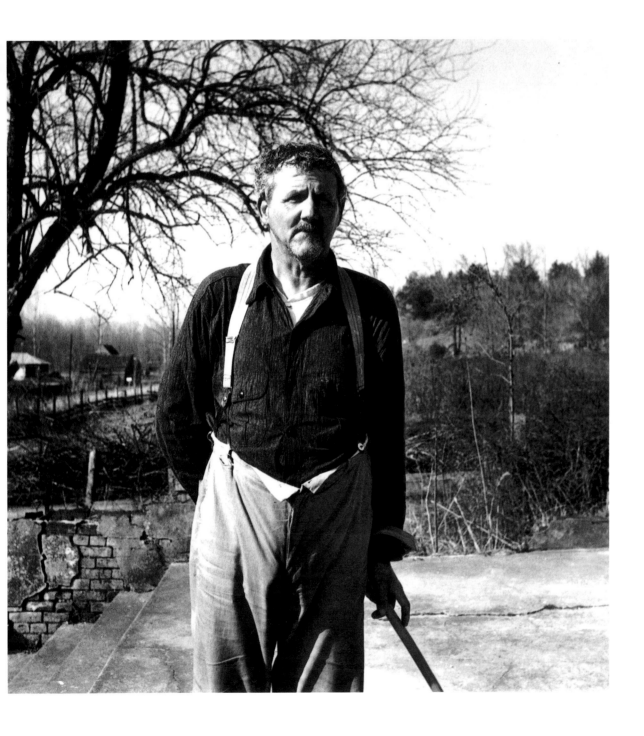

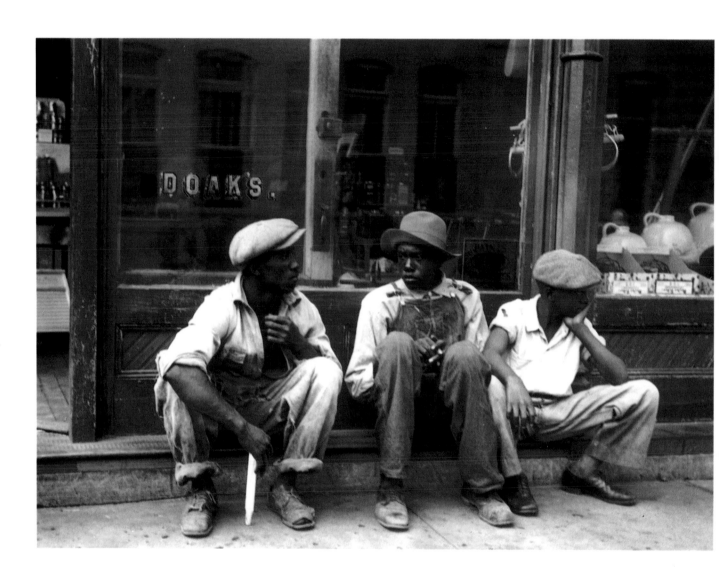

29. Baptist deacon / Jackson / 1930s

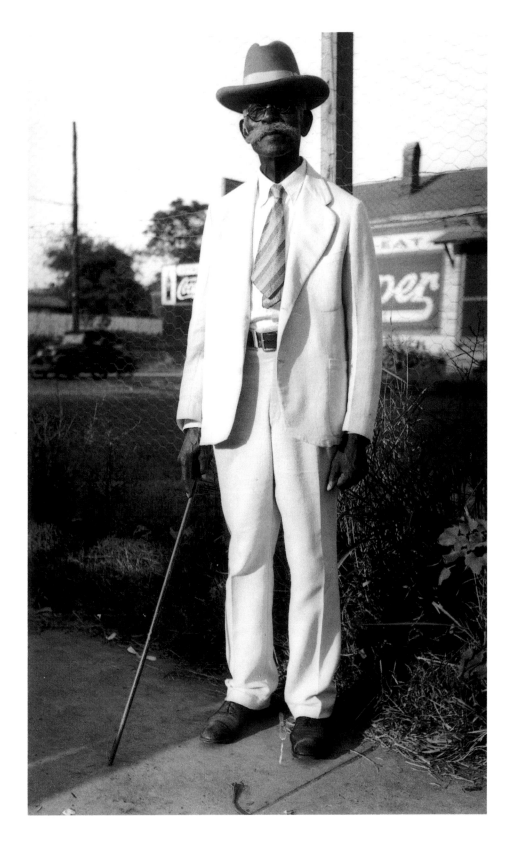

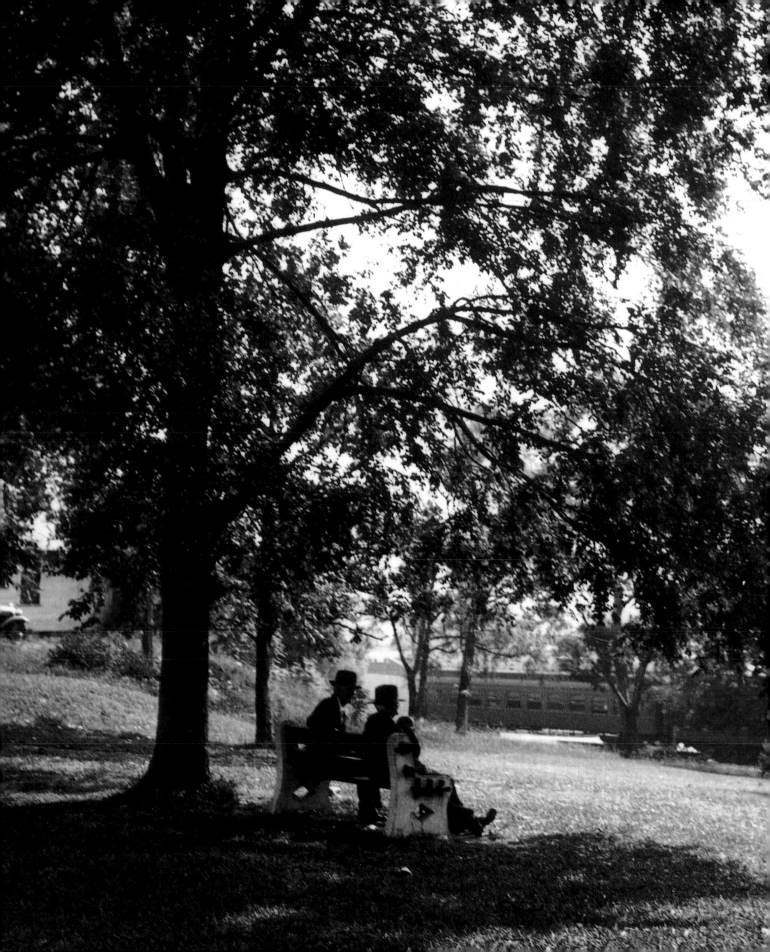

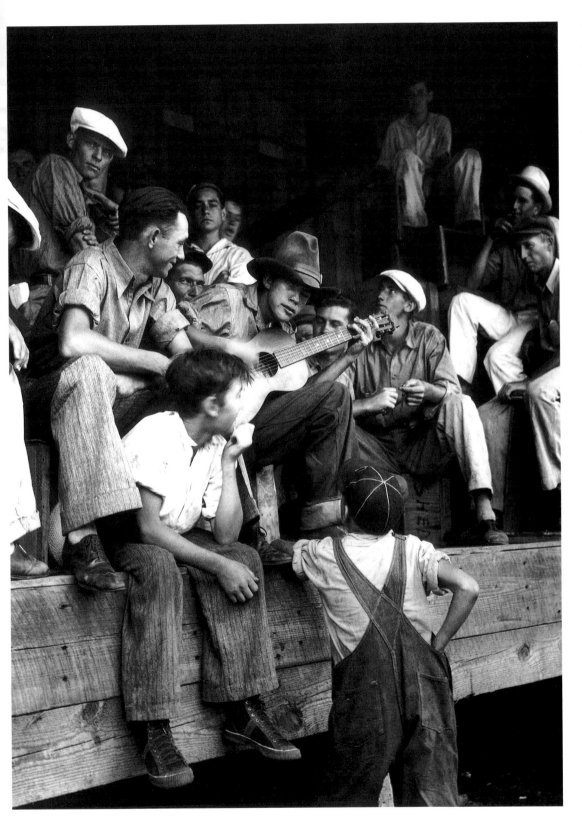

30.
Confederate
veterans
meeting in
the park /
Jackson / 1930s
31.
Tomato-
packers'
recess /
Copiah County /
1936

32. Hog-killing time / Hinds County /
1930s

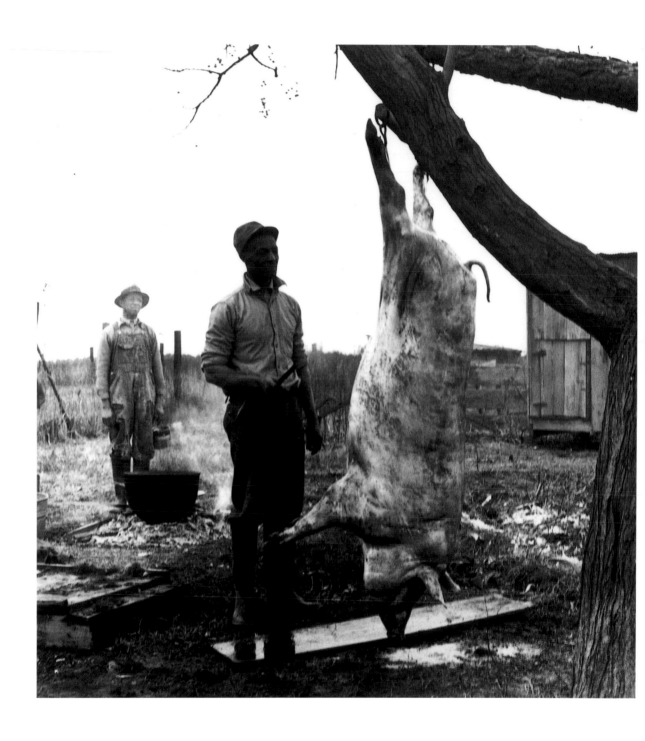

33. Making cane syrup / Madison County /

1930s

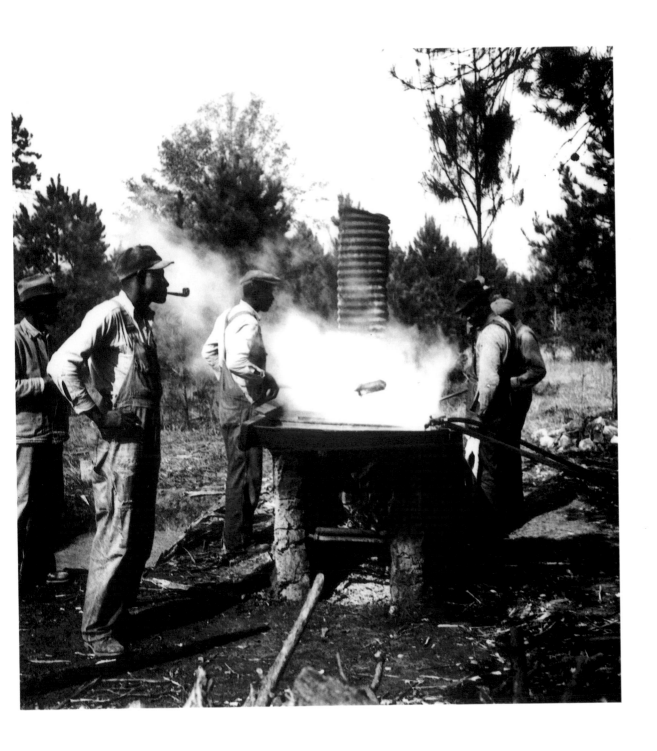

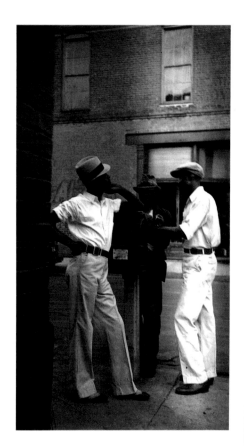

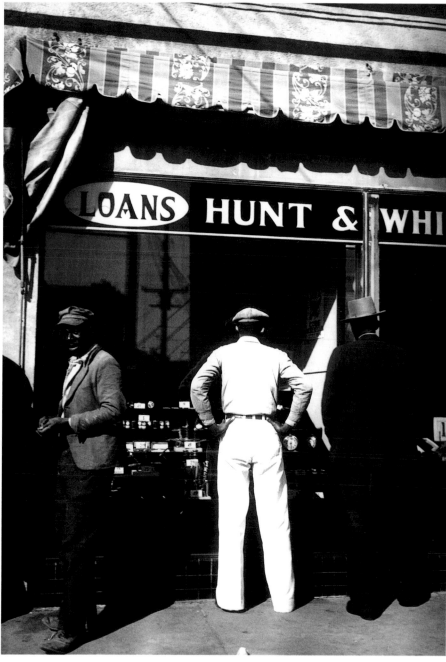

36.
*Political rally
on the
courthouse
grounds /
Pontotoc / 1930s*

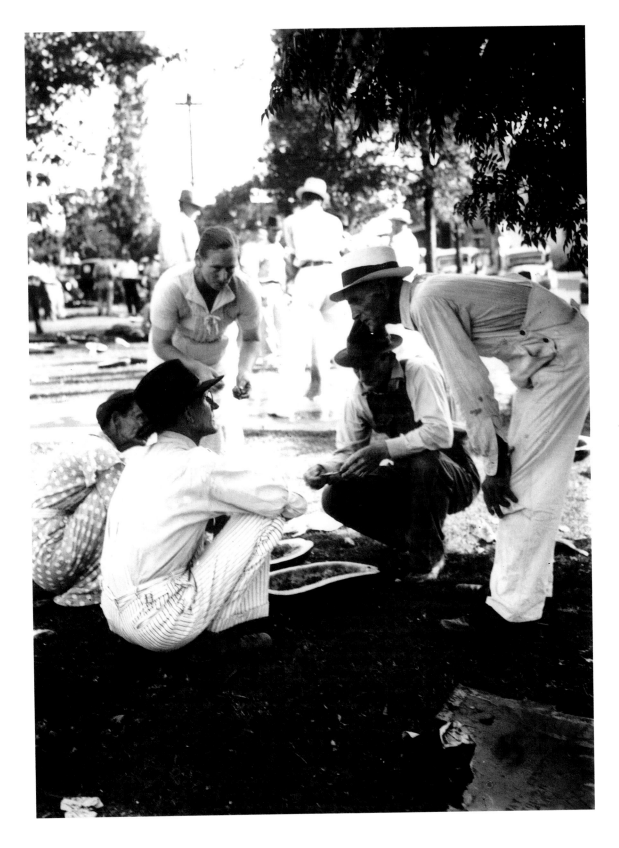

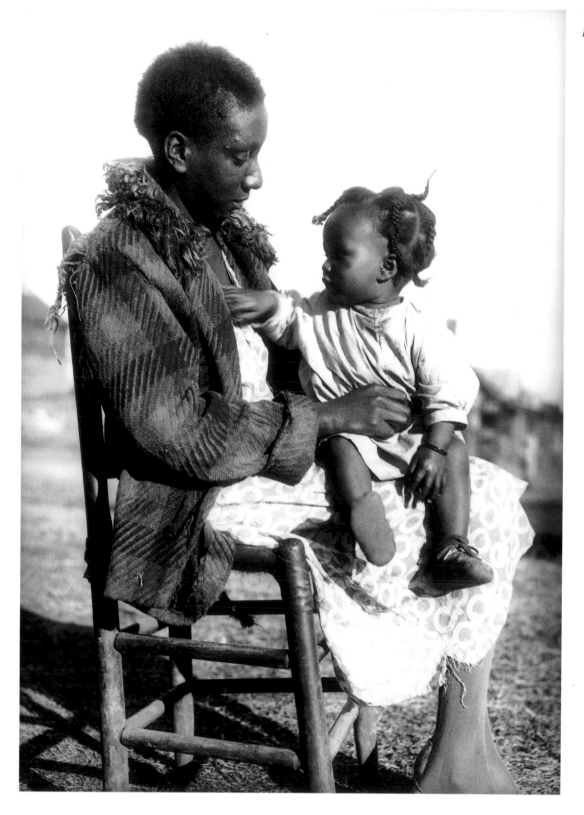

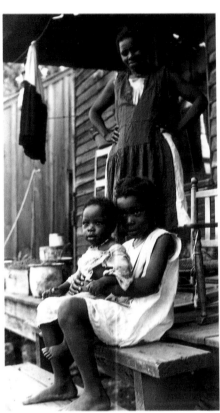
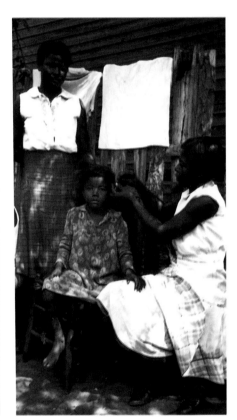

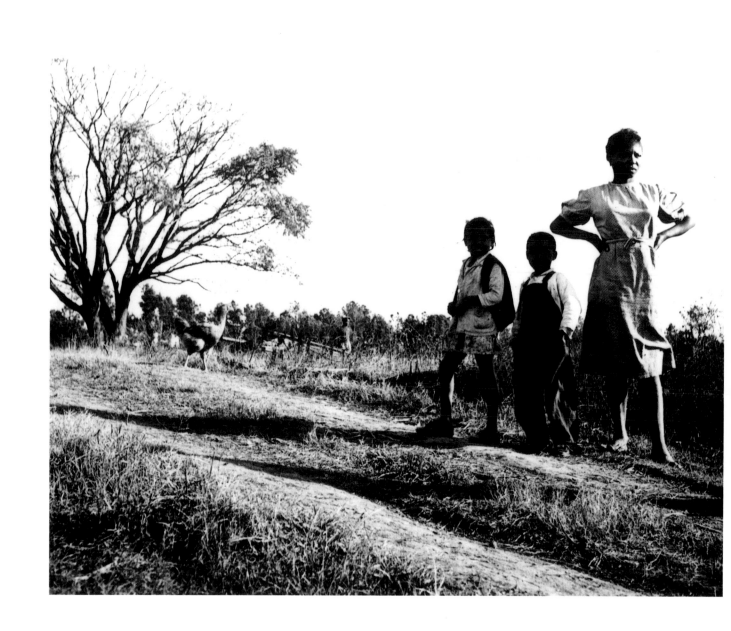

41. *Too far to walk it / Star / 1930s*
42. *Plum pickers / Copiah County / 1930s*

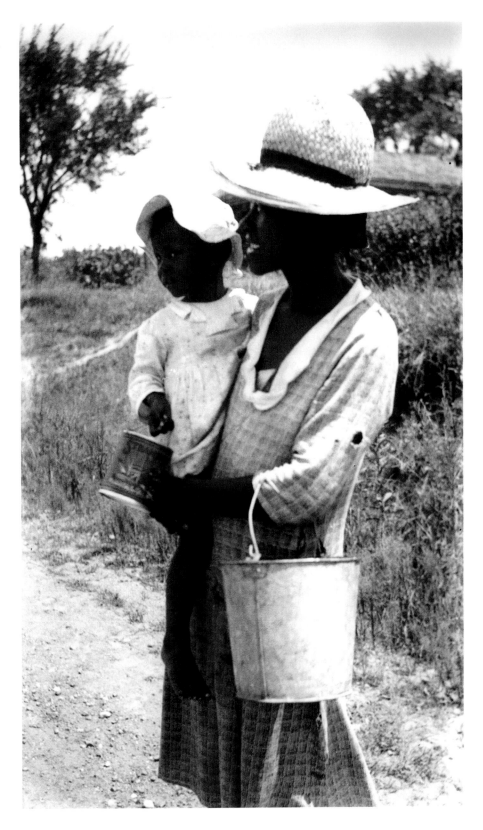

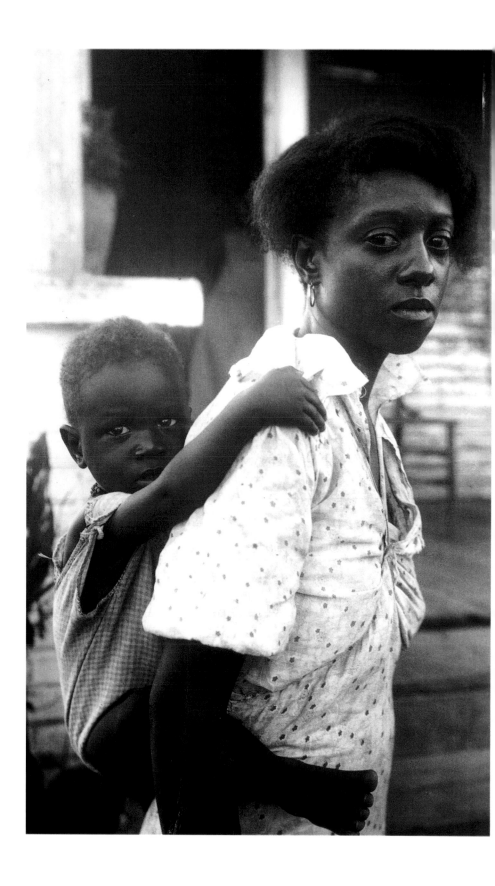

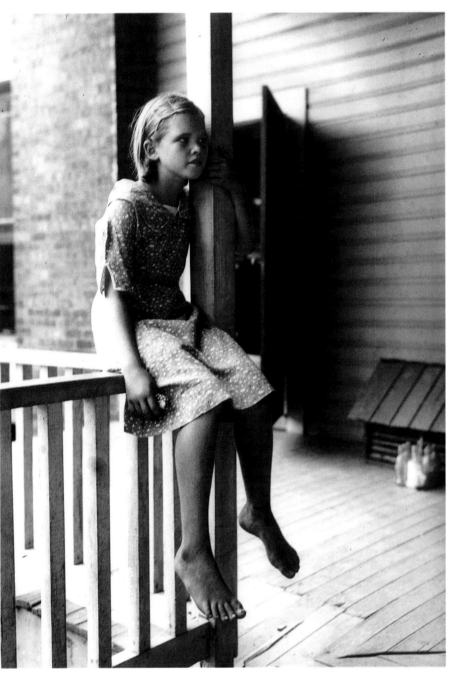

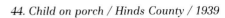
44. *Child on porch / Hinds County / 1939*

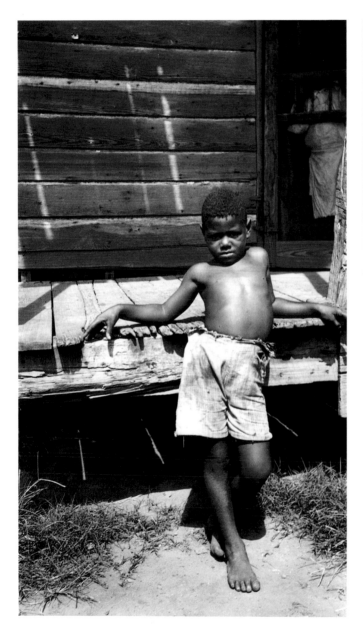

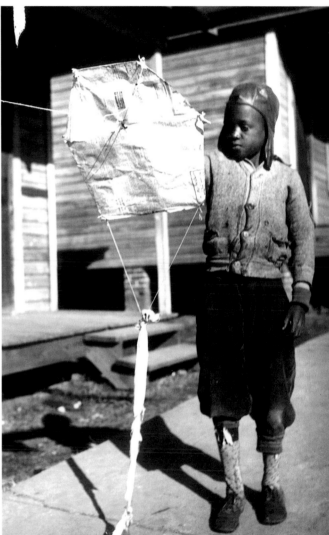

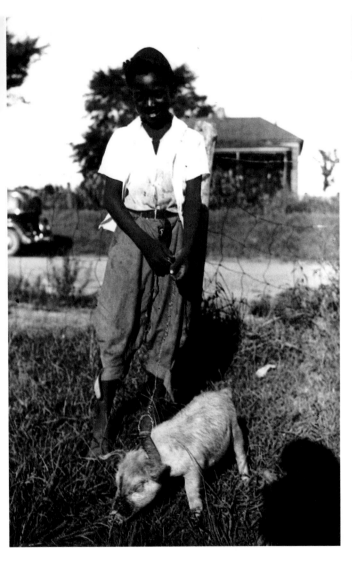

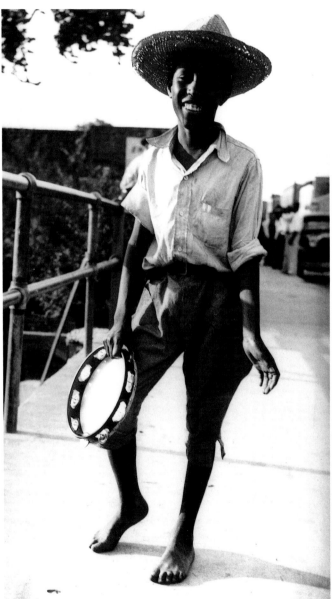

49. Brothers / Jackson / 1930s

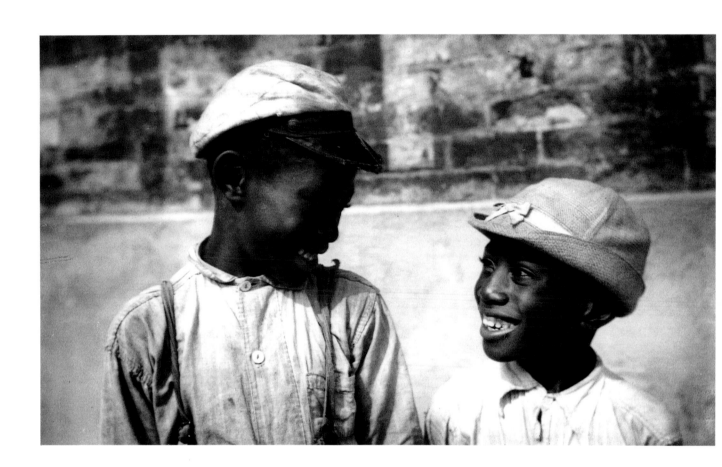

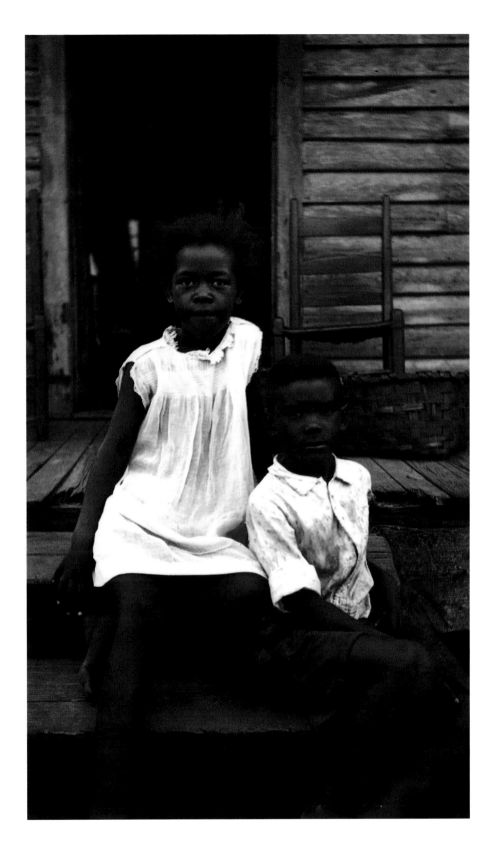

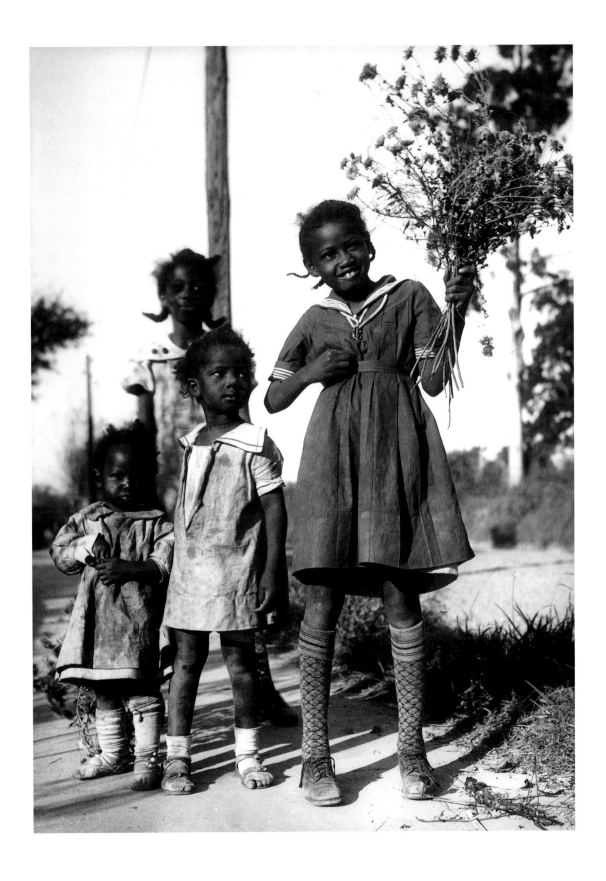

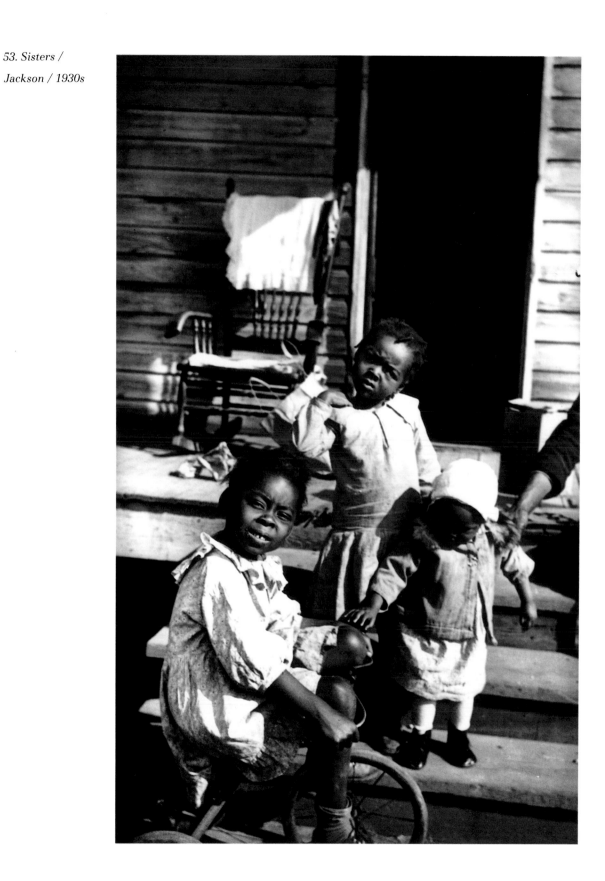

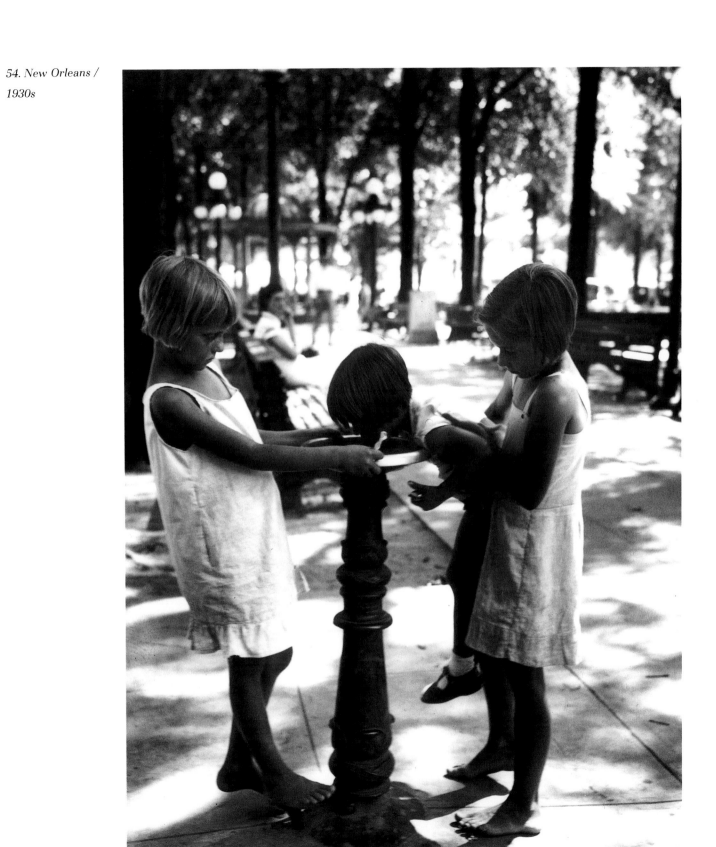

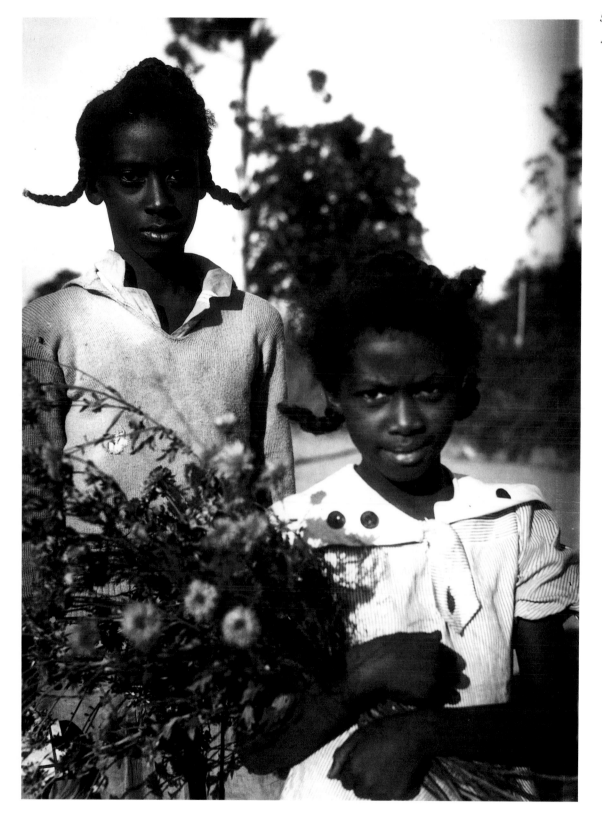

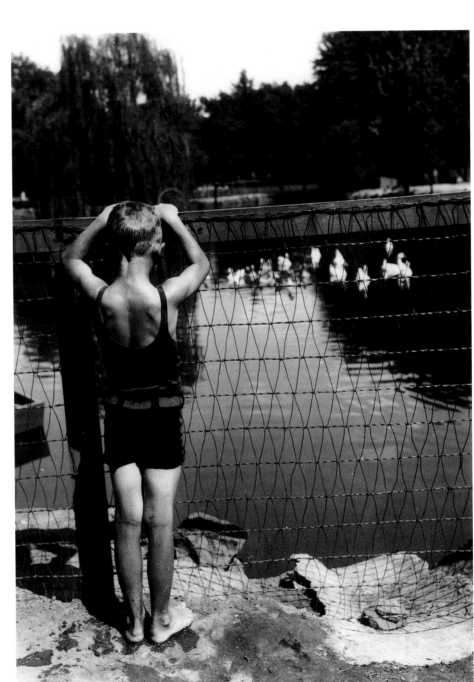

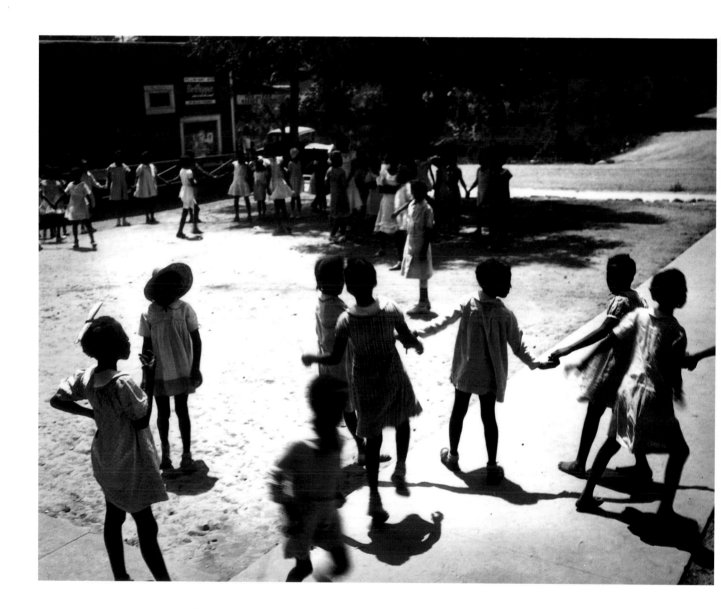

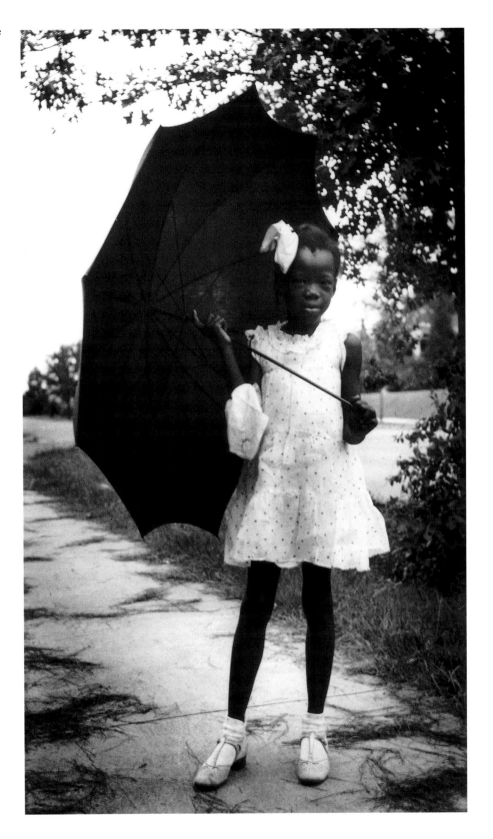

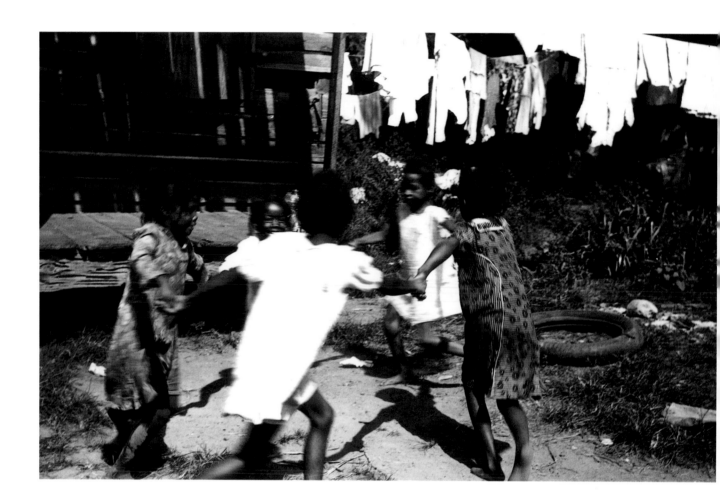

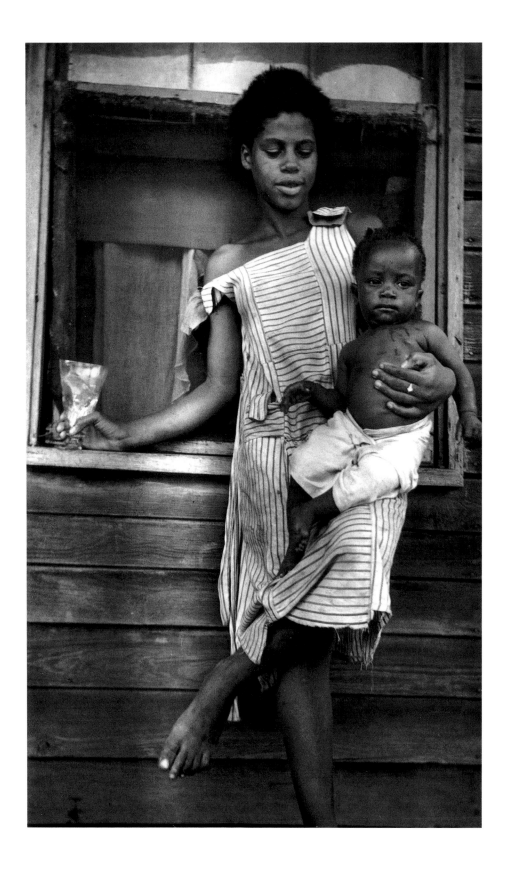

61. Home / Jackson / 1930s

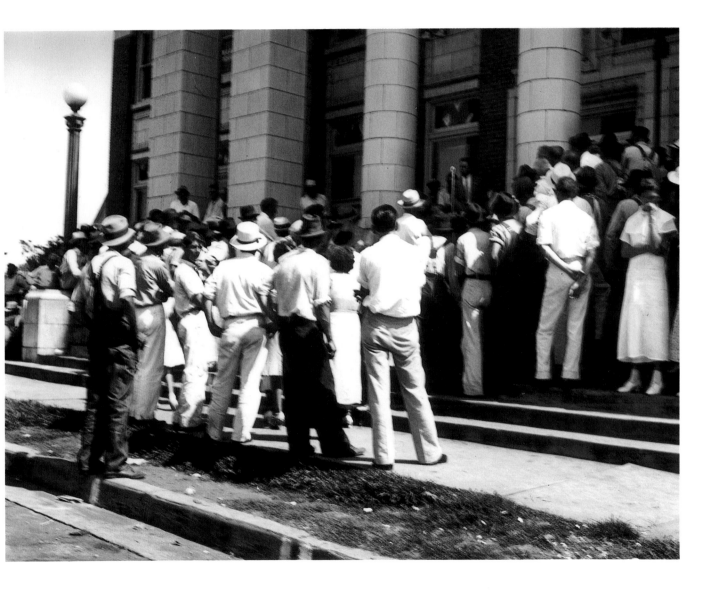

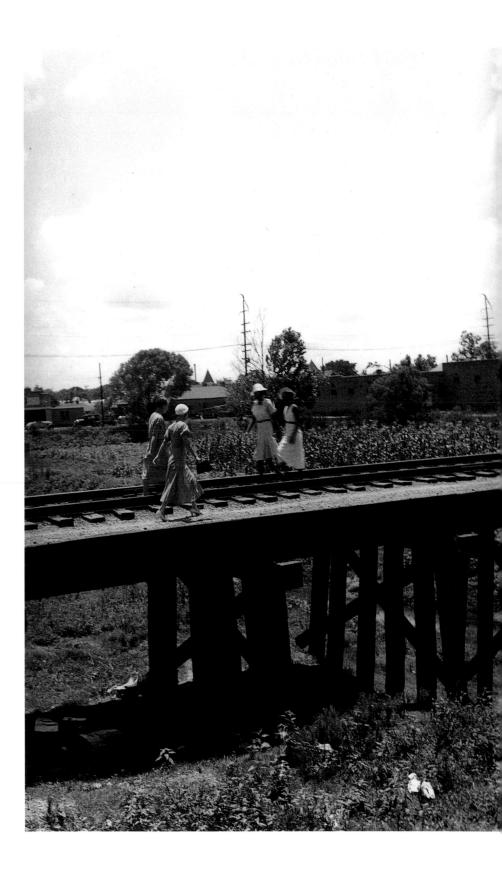

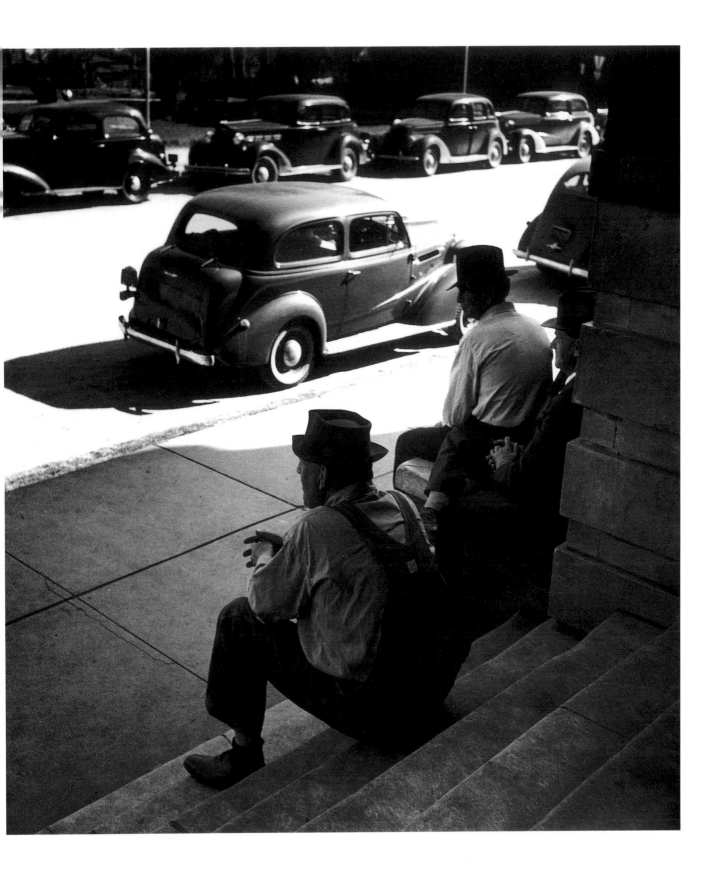

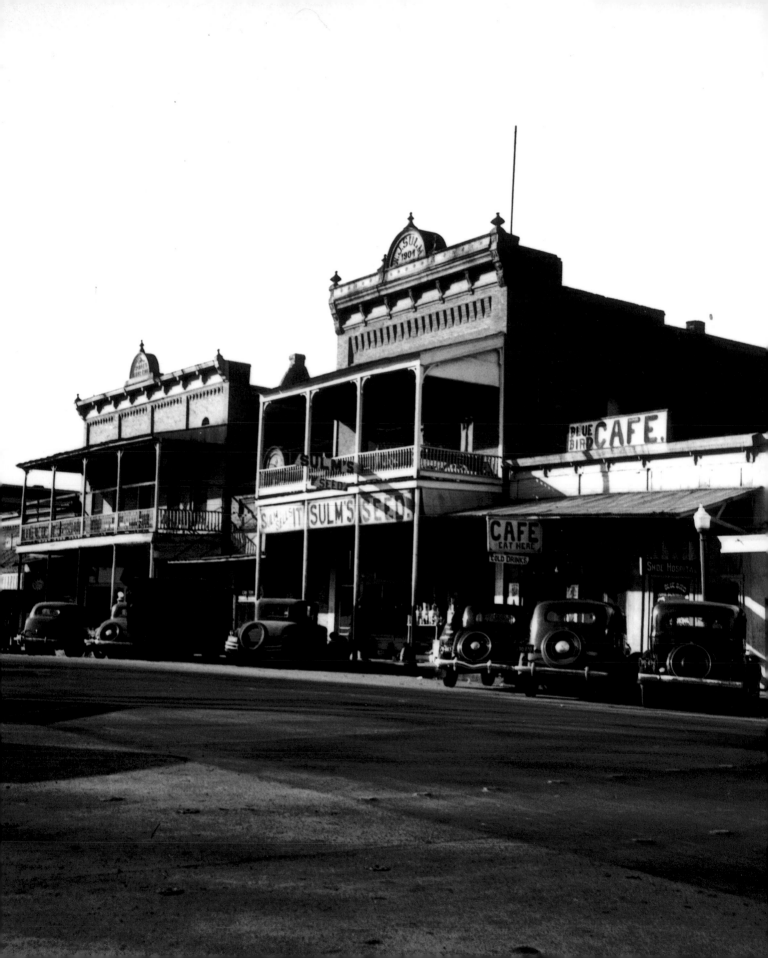

65. *Town square / Canton / c. 1935*

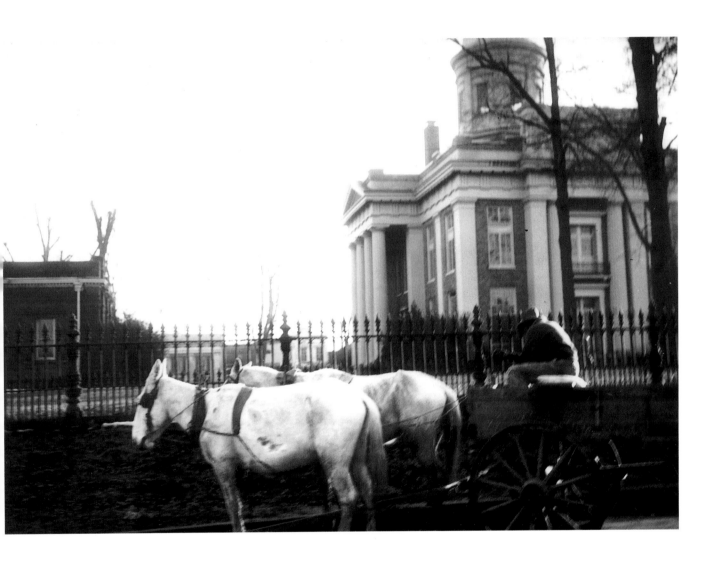

66. *Mule-drawn wagon / Canton /*

c. 1935

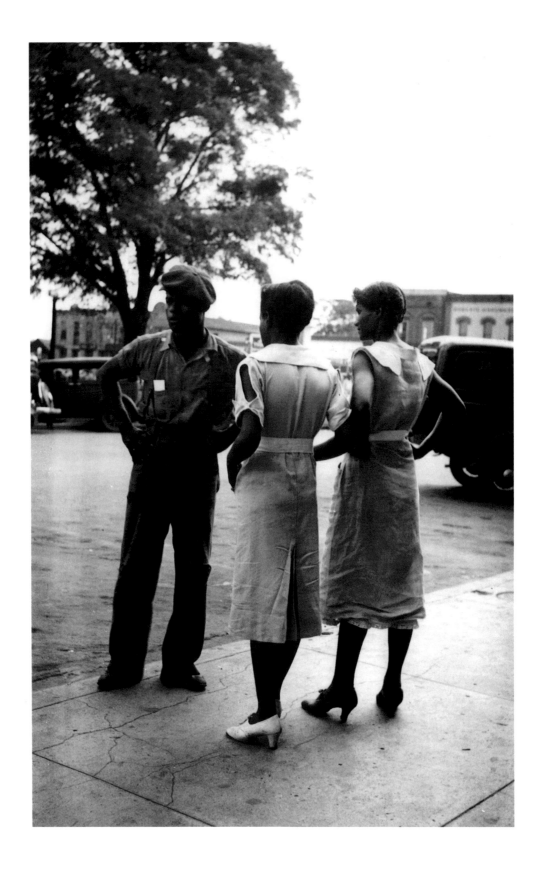

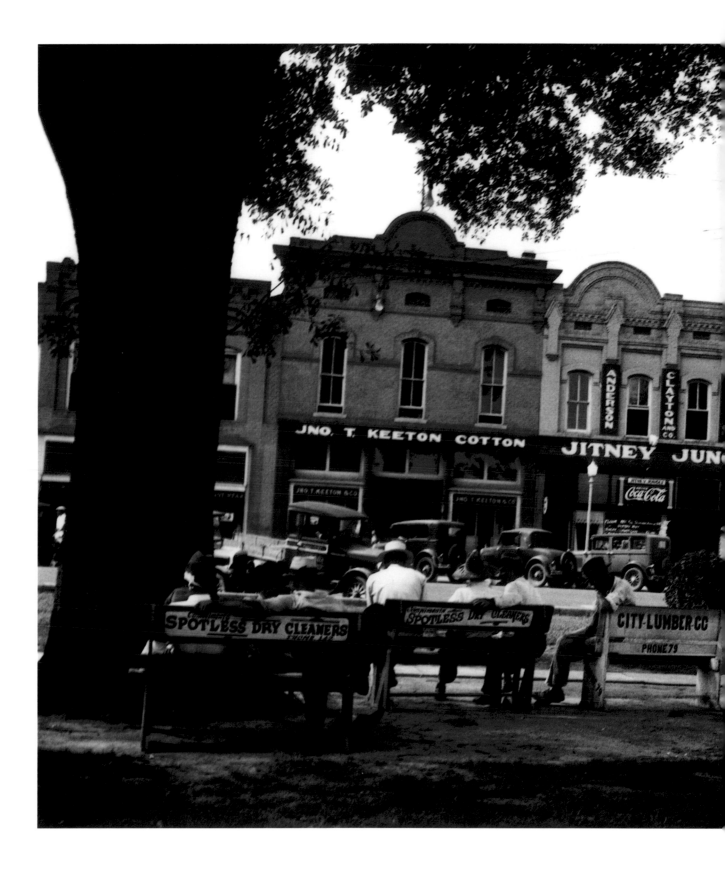

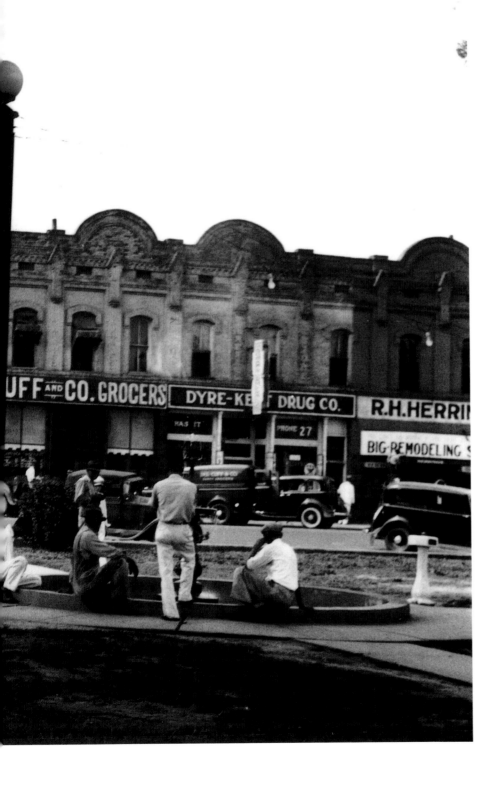

69. Courthouse town / Grenada / 1935

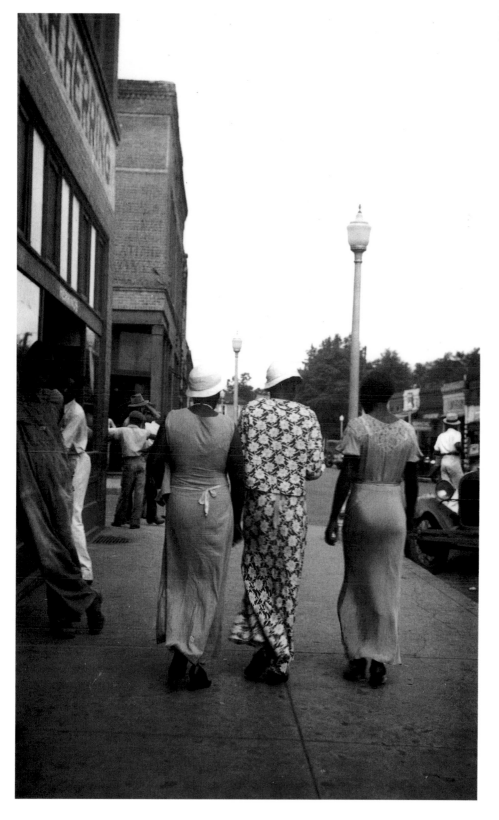

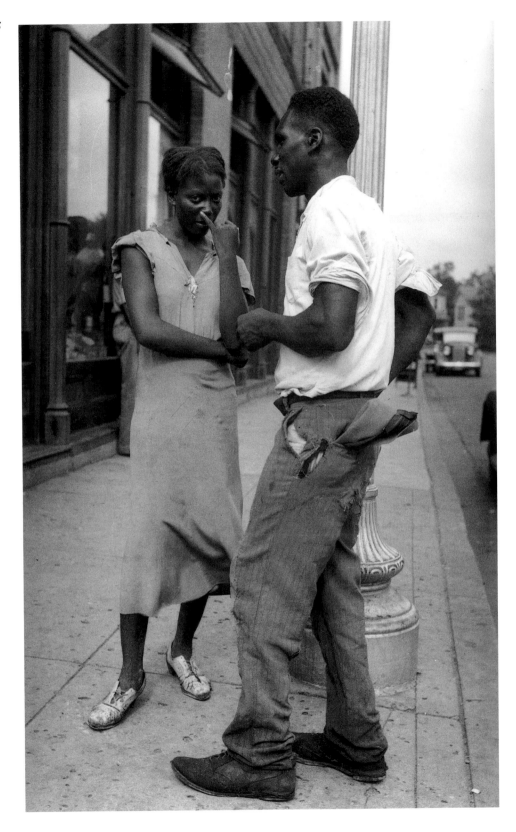

72. Town of tin / Hermanville / 1930s

73. Crystal Springs / 1930s

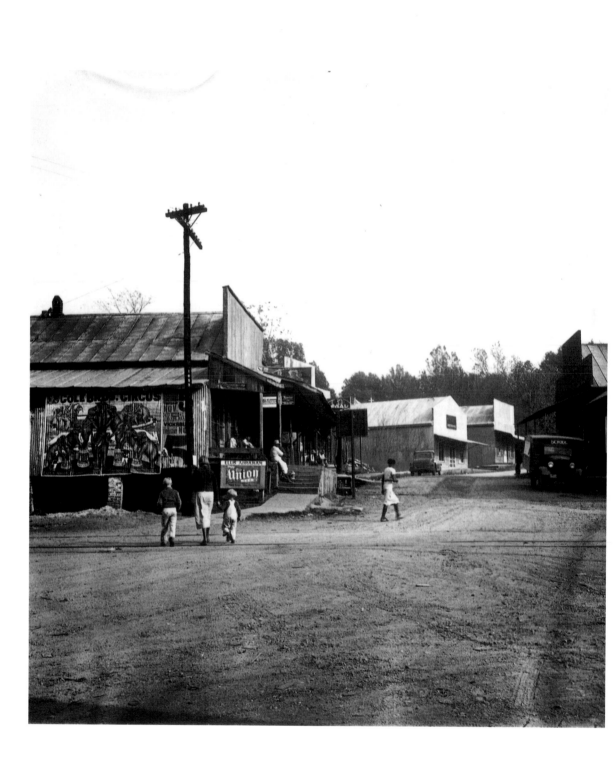

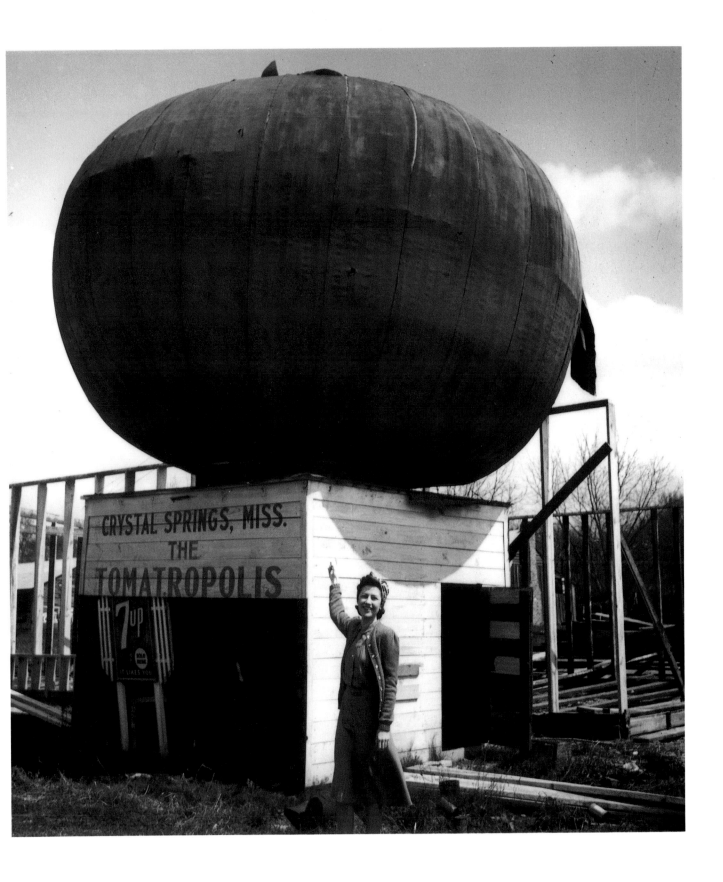

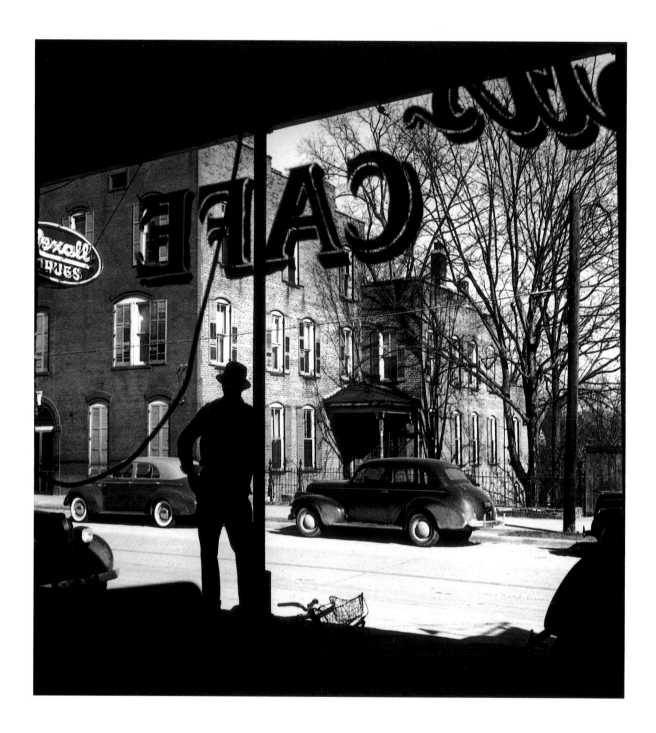

74. Fayette / 1930s

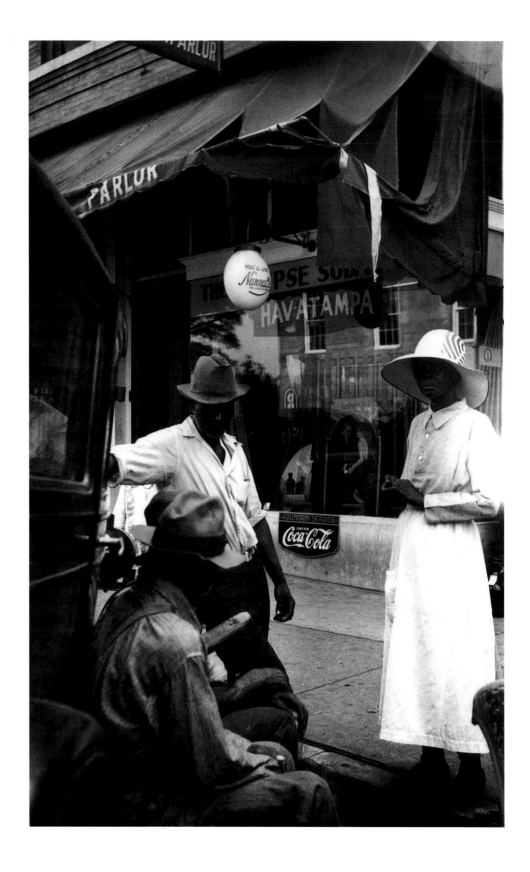

77. *Club float, Black State Fair parade /*

Jackson / 1930s

78. *Church float, State Fair parade /*

Jackson / 1930s

79. *County float, State Fair parade /*

Jackson / 1930s

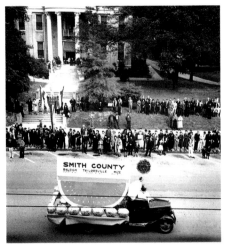

80. Club float, Black State Fair parade /
Jackson / 1930s

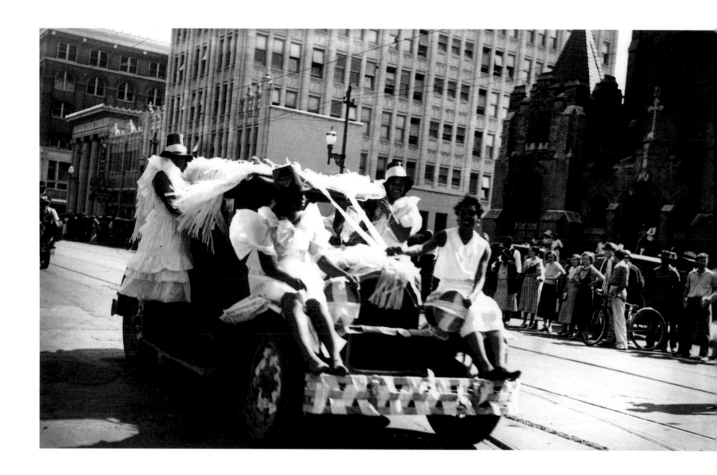

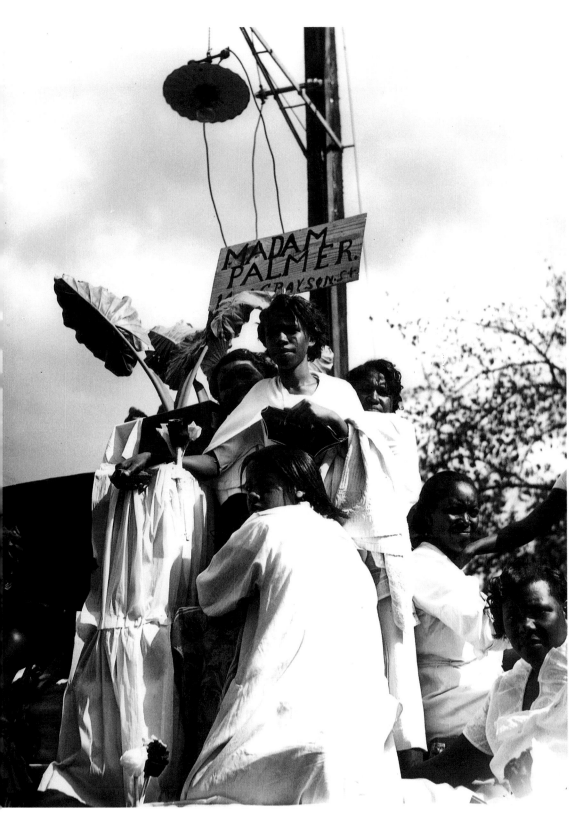

81.
Parade float /
Jackson /
1930s

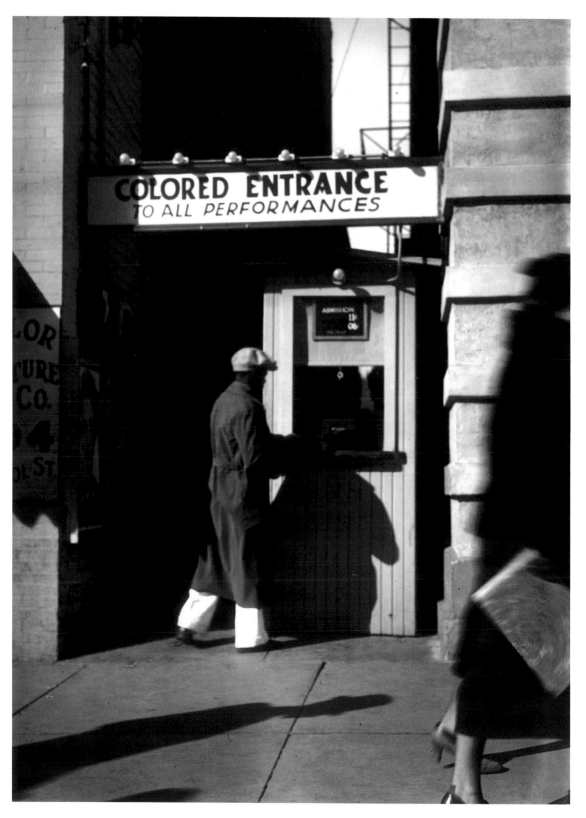

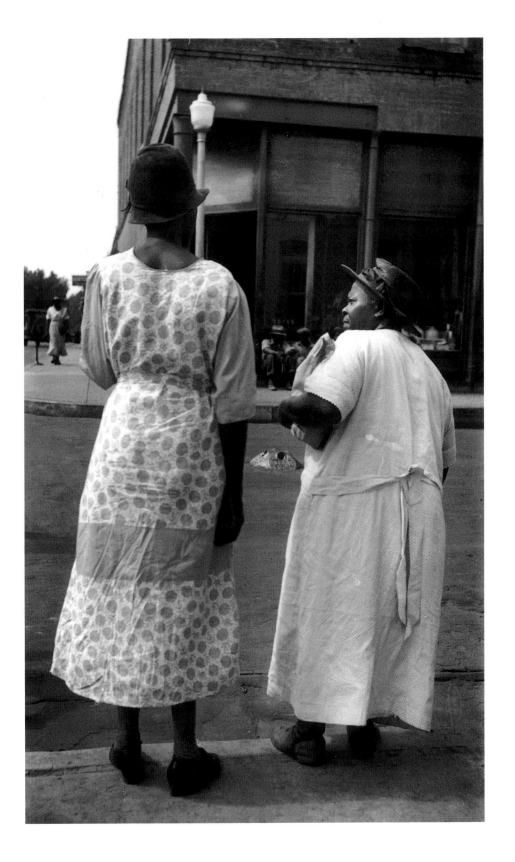

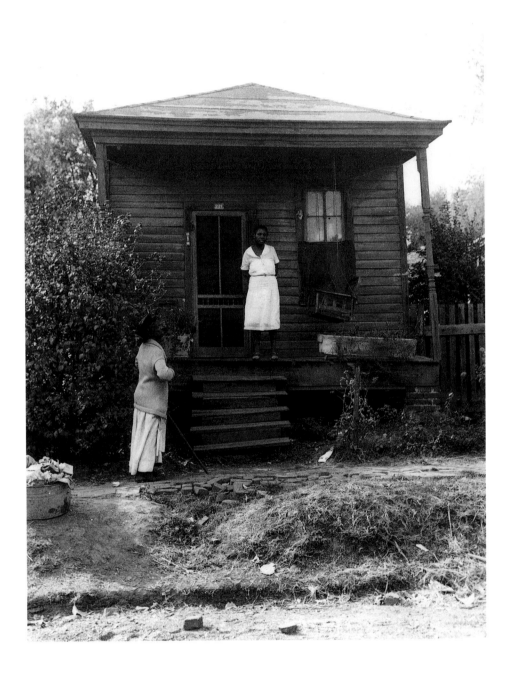

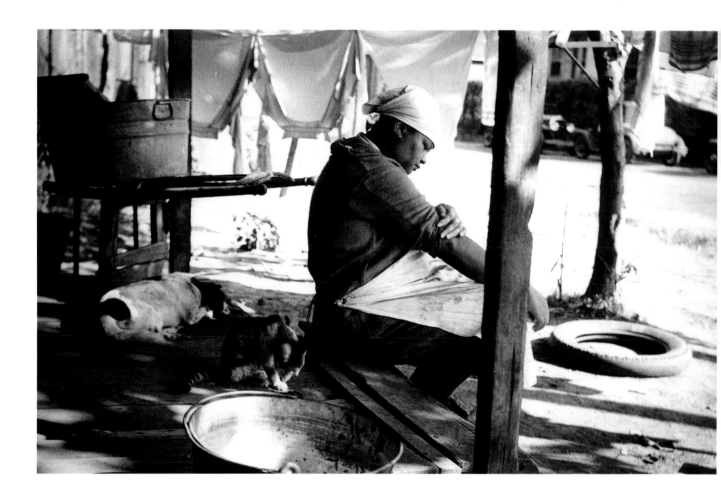

87. *The mattress factory / Jackson / 1930s*

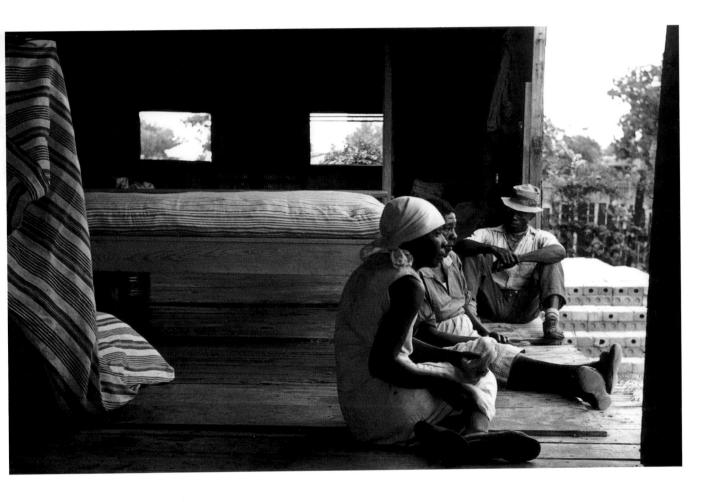

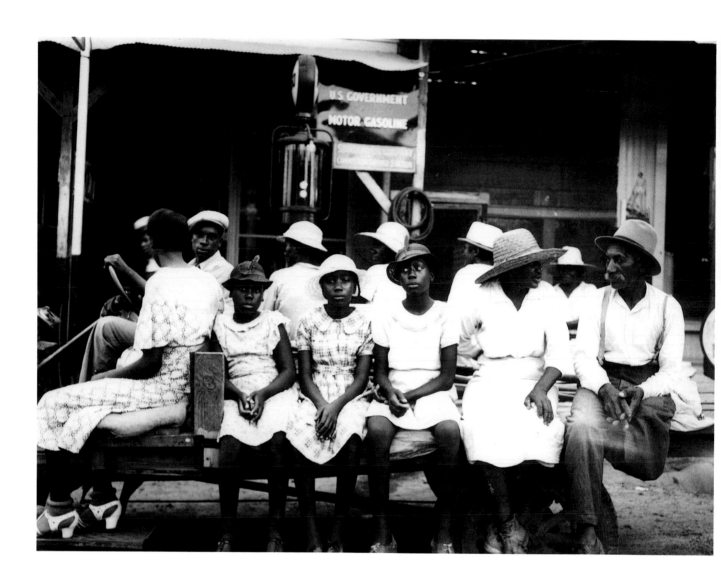

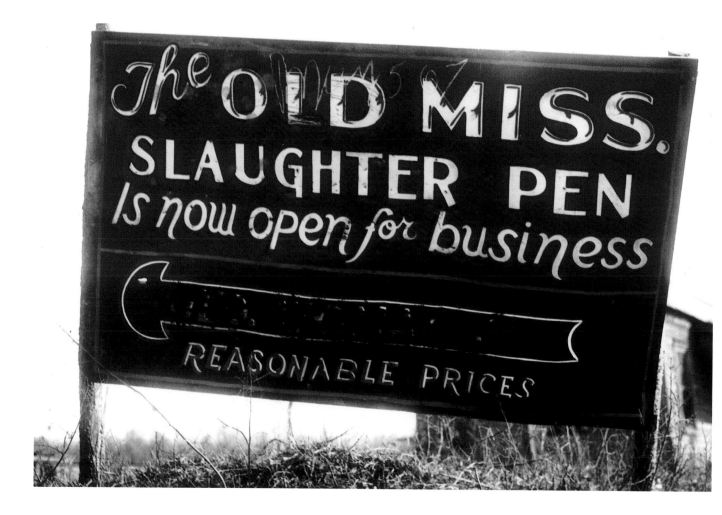

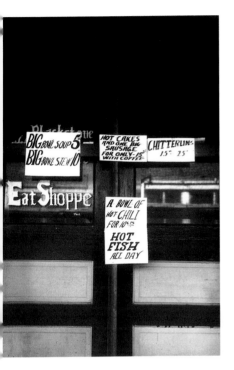

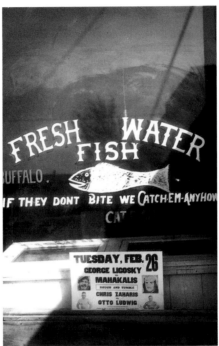

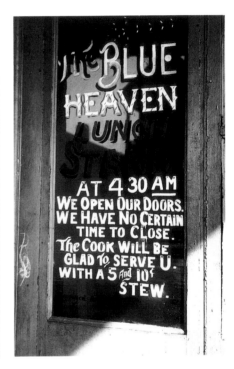

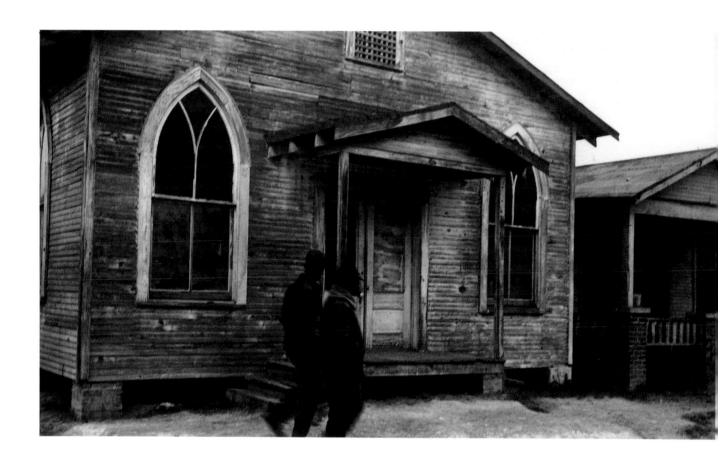

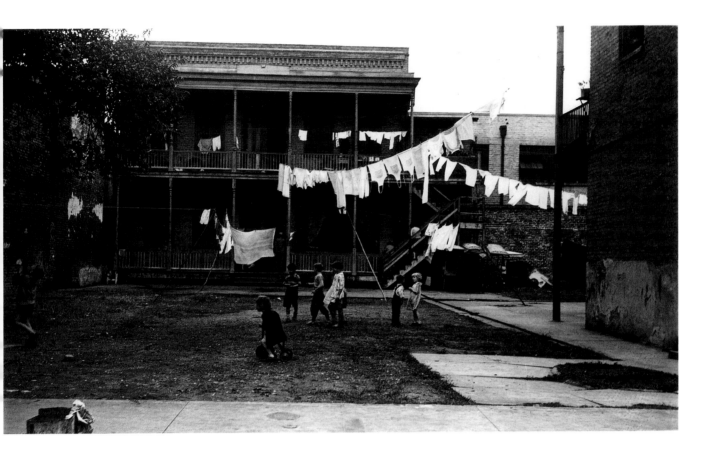

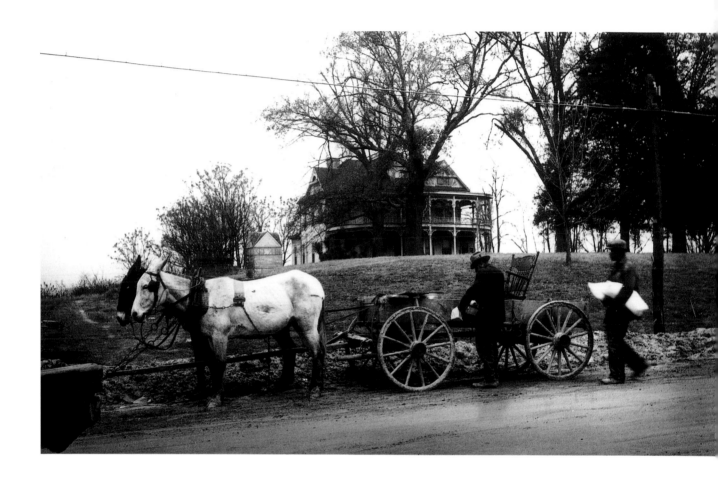

97. Church / Port Gibson / 1930s

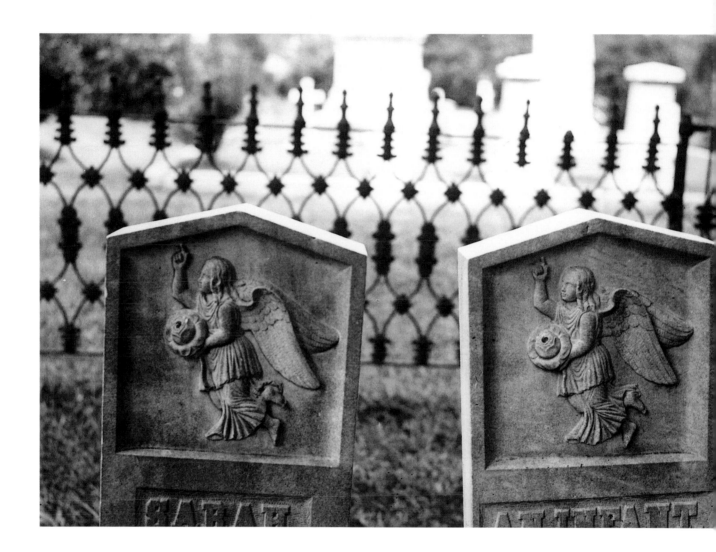

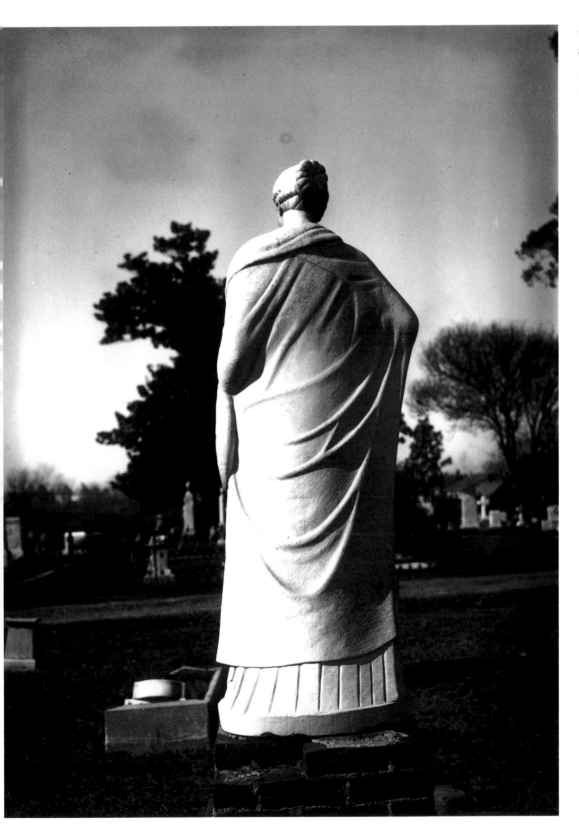

99. Cemetery
monument /
Mississippi /
1930s

100. Members of a Pageant of Birds,
Farish Street Baptist Church /
Jackson / 1930s
101. Bird Pageant costumes / Jackson /
1930s
102. Bird Pageant / Jackson / 1930s

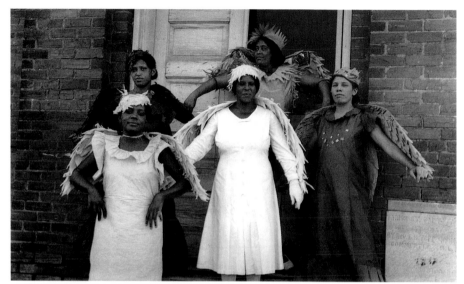

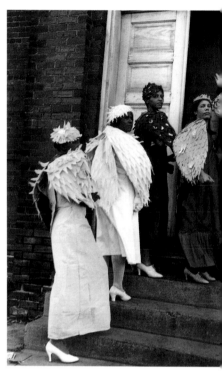

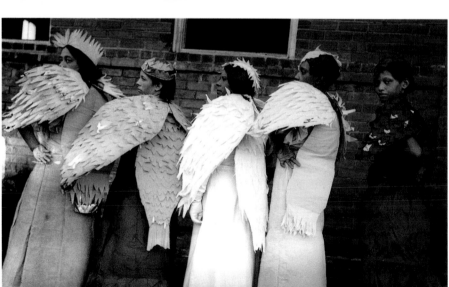

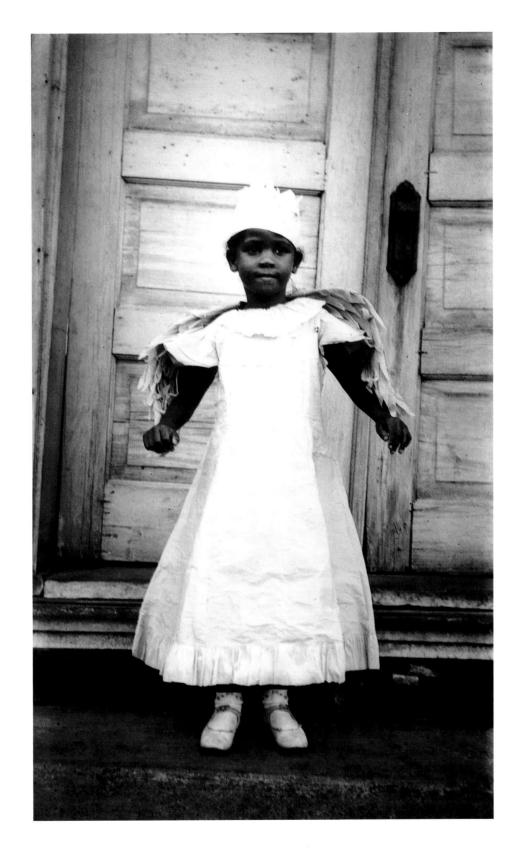

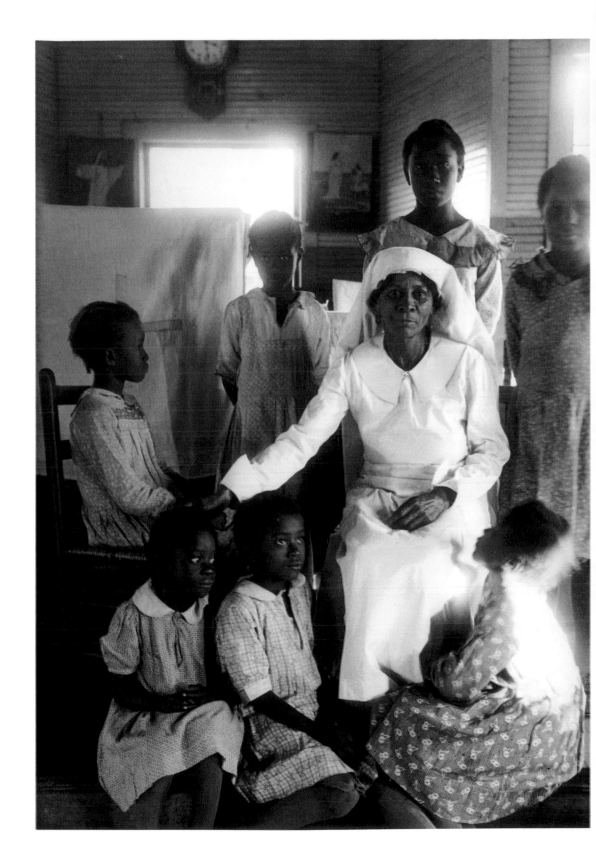

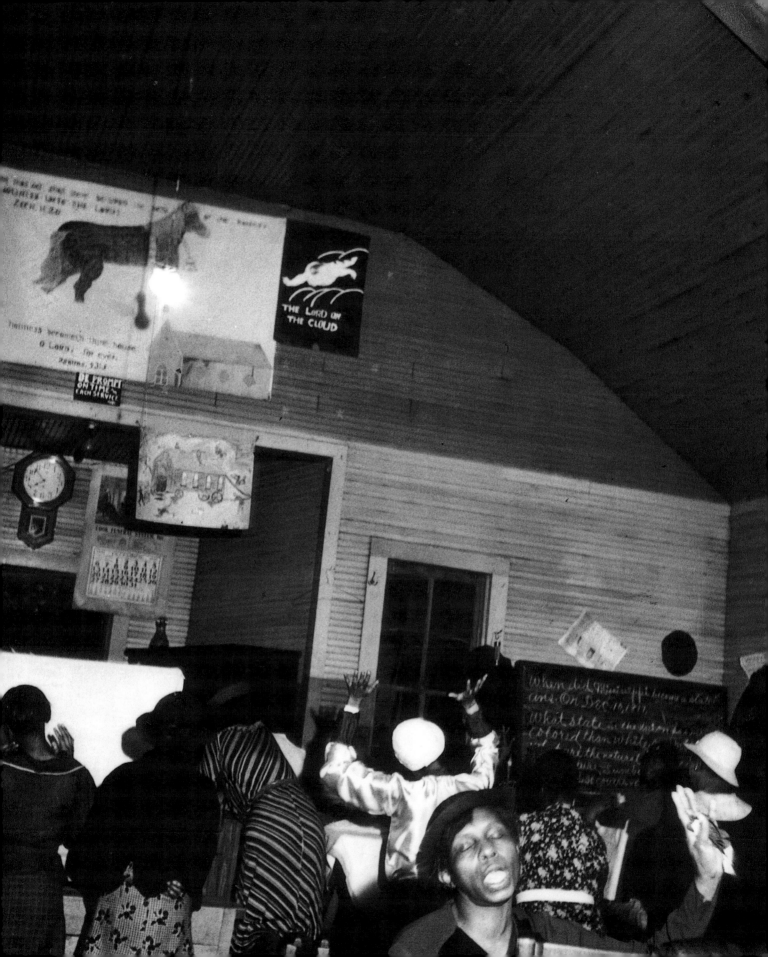

106.
Baby Holiness
member,
Holiness
Church /
Jackson / 1939

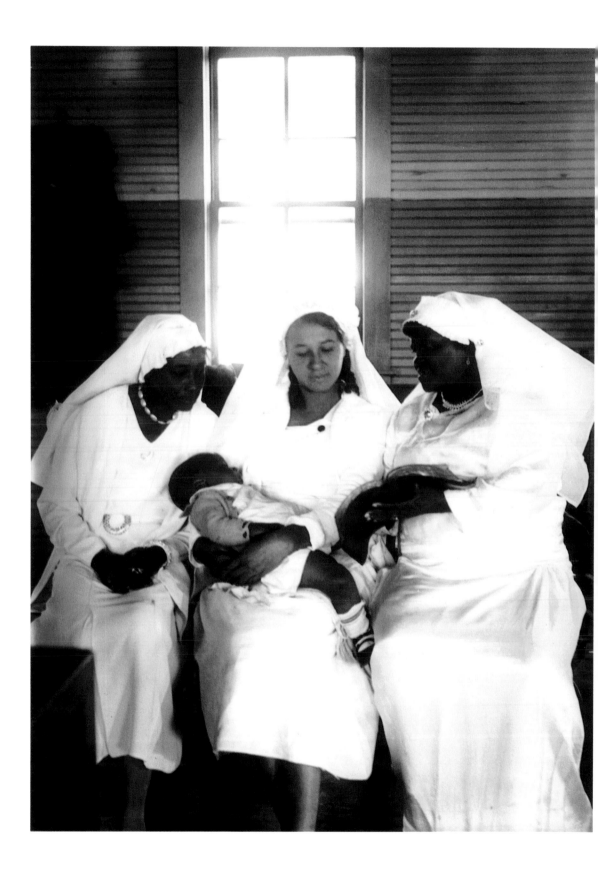

107.
Preacher and
leaders of
Holiness
Church /
Jackson / 1939

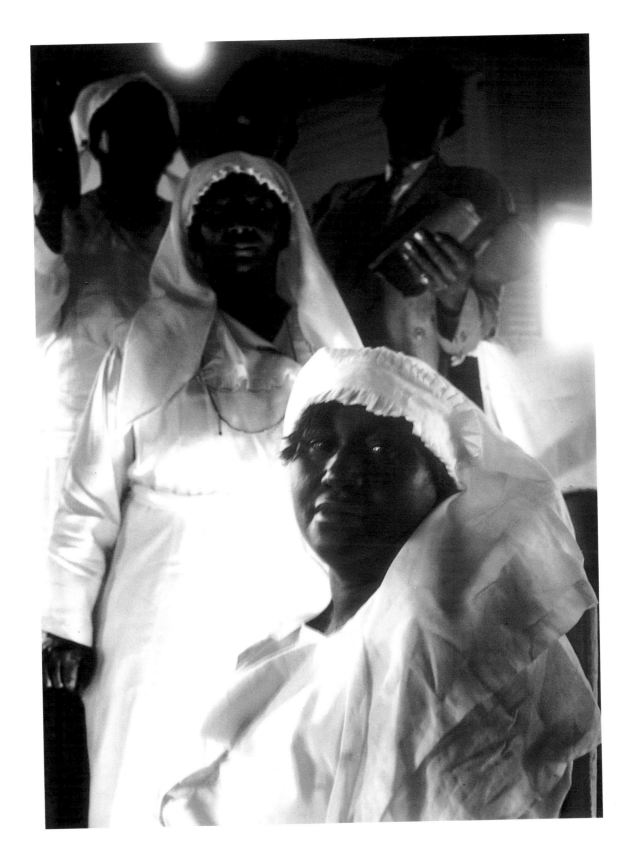

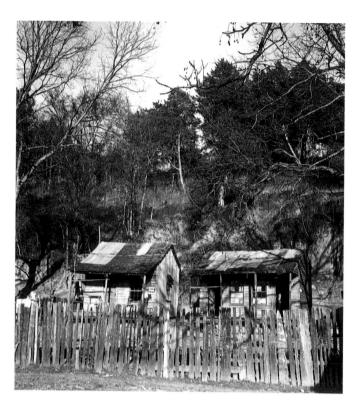

111. Home, ghost river-town / Rodney /
1930s

112. Backyard / Rankin County / 1930s

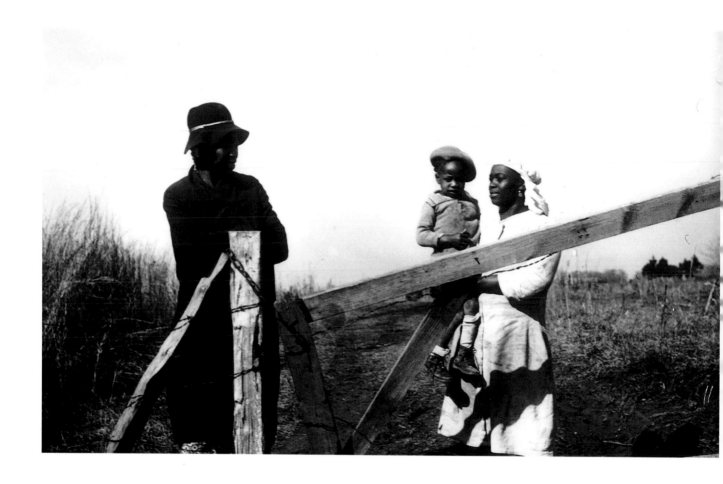

114. Washwomen carrying the clothes /

Yalobusha County / 1930s

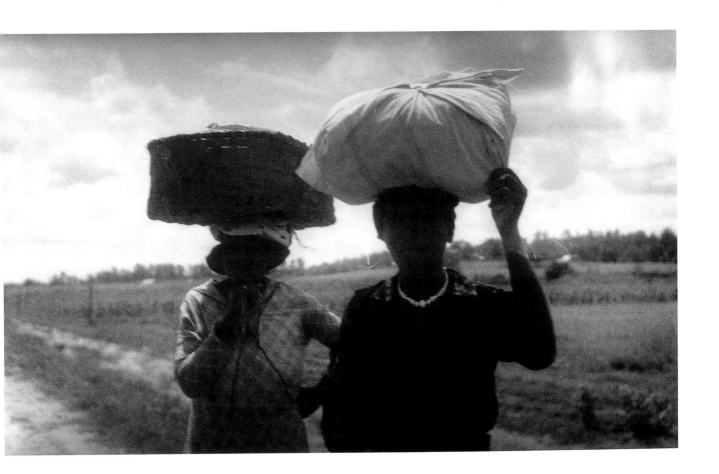

115. Home by dark /
Yalobusha County /
1936

117. *Home abandoned, old Natchez*
Trace / near Clinton / 1930s
118. *Catholic Church / Rodney / 1940s*

Overleaf:
119. *Ruins of Windsor / Port Gibson /*
1942
120. *Country church / Rodney / 1940s*

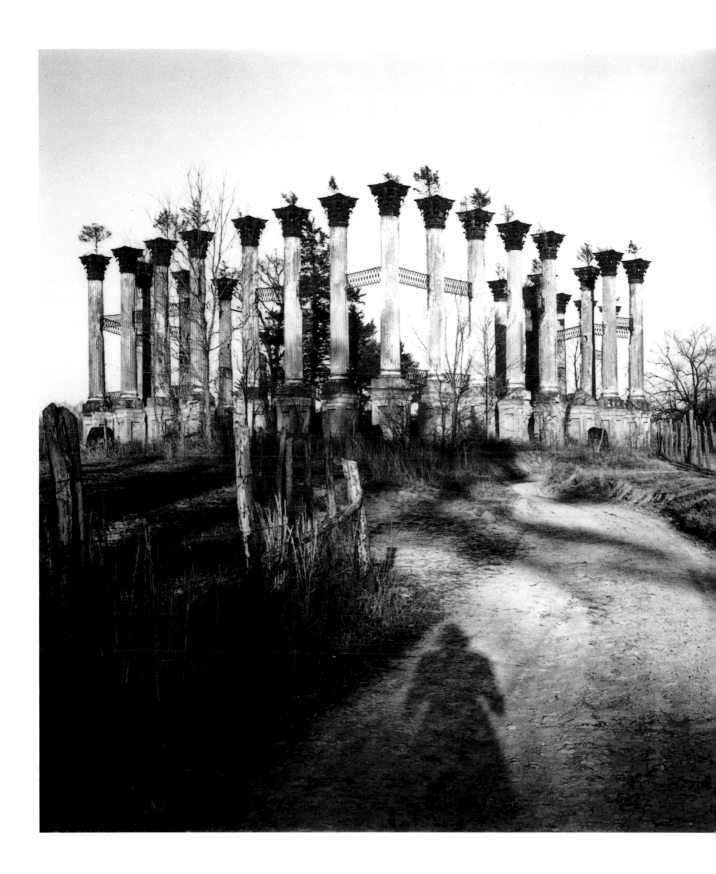

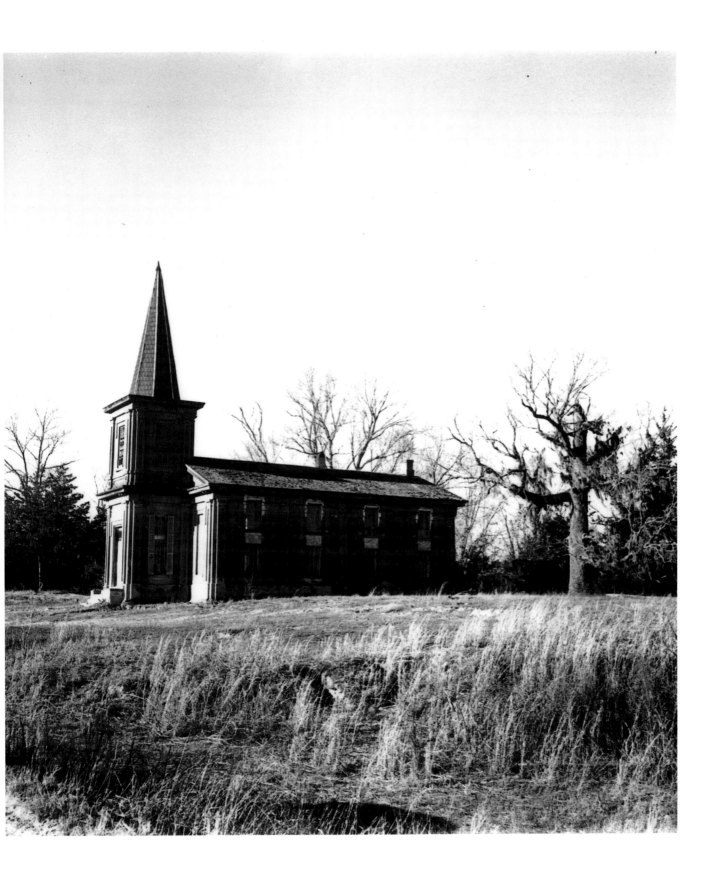

121. House with bottle-trees / Simpson County / 1941

122. Suspension bridge / Strong River / 1940s

Overleaf:

123. Country church / near Old Washington / 1940s

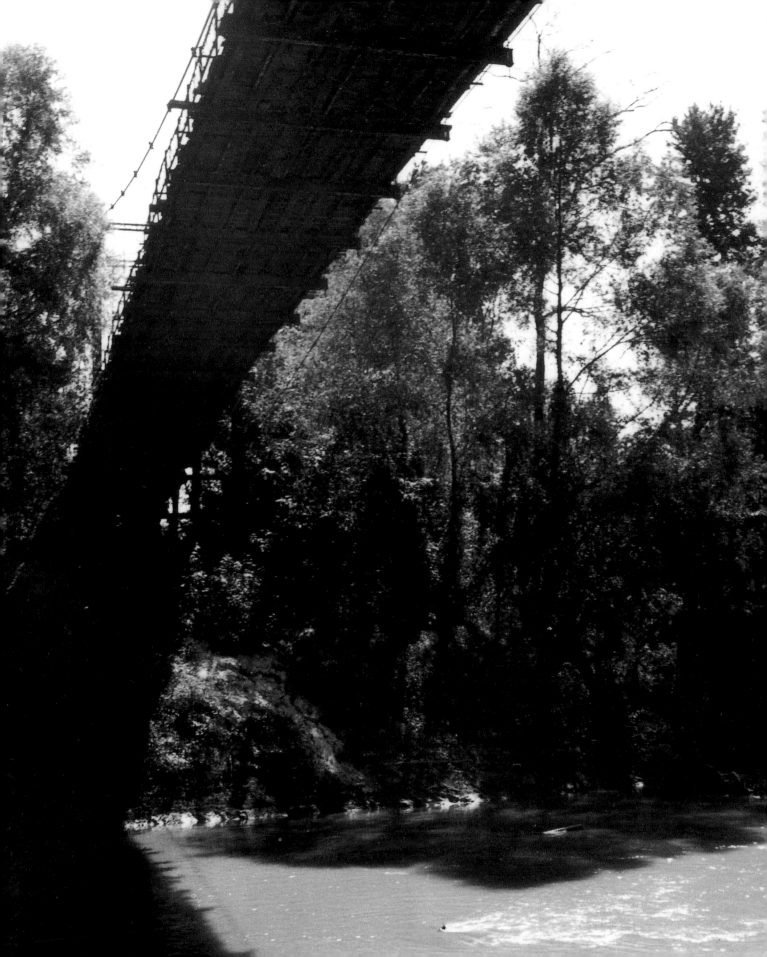

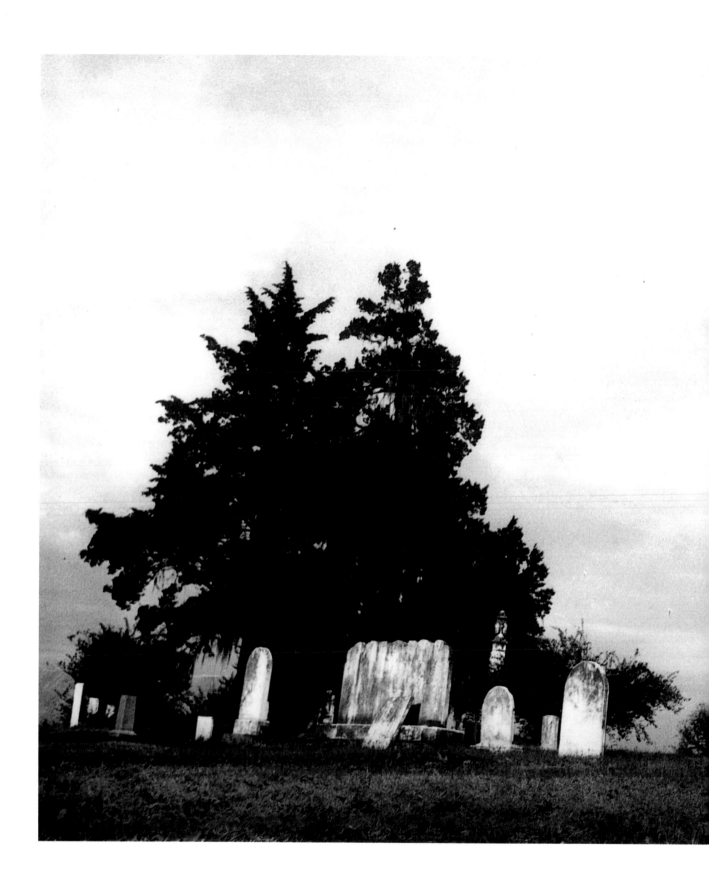

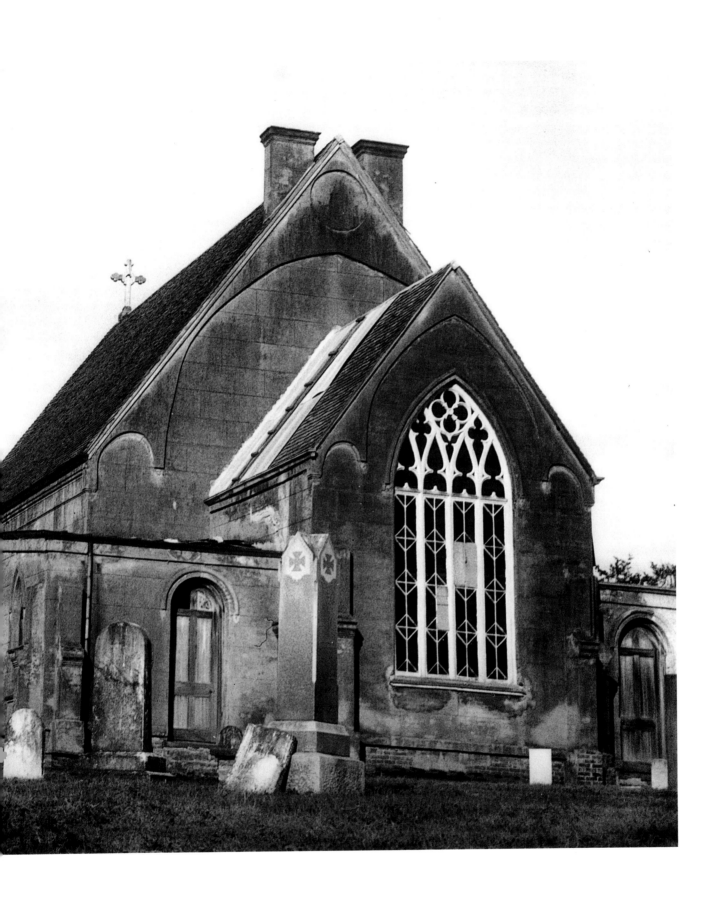

124. *Ghost river-town / Rodney / 1942*
125. *Road between high banks / Hinds County / 1940s*

126.
Free gate,
State Fair /
Jackson / 1939

27. Fiddler at Fair gate with jigging
dolls / Jackson / 1939

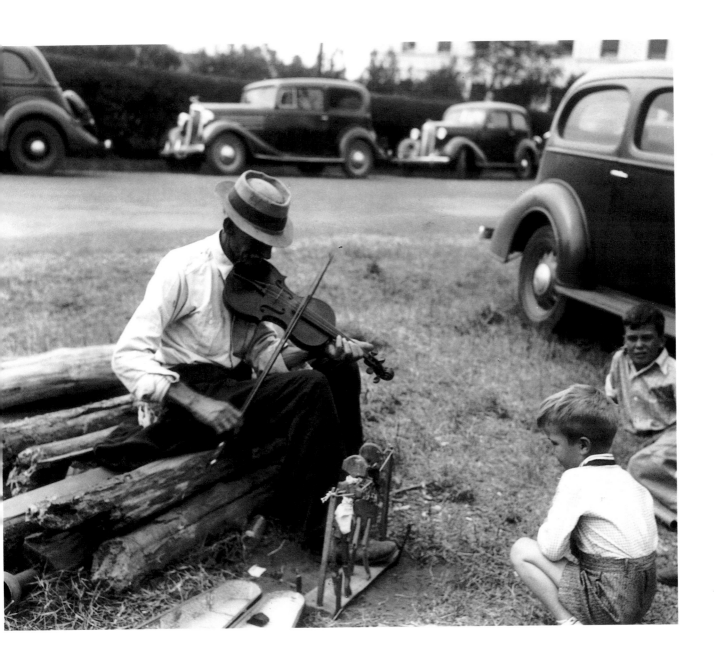

128. *Carnival work crew / Jackson / 1939*
129. *Here it comes! / Jackson / 1930s*

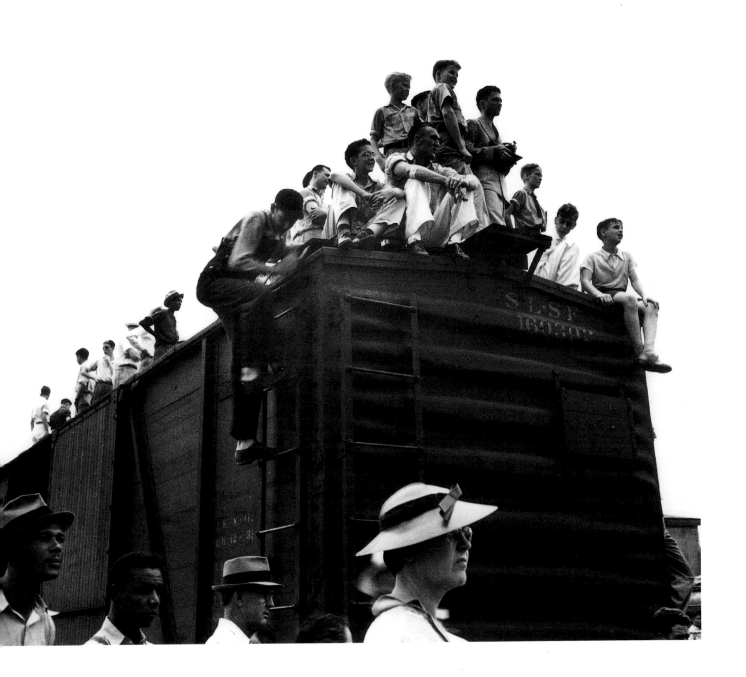

130. Ticket office, State Fair /
Jackson / 1939

131. Sideshow, State Fair /
Jackson / 1939

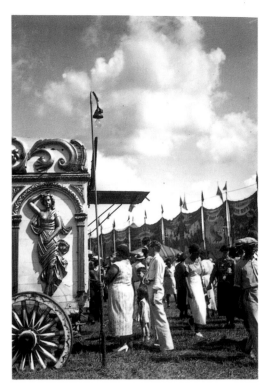

132, 133, 134, 135. Sideshow, State Fair /
Jackson / 1939

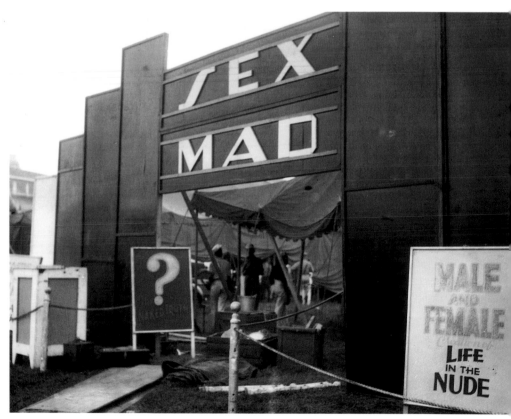

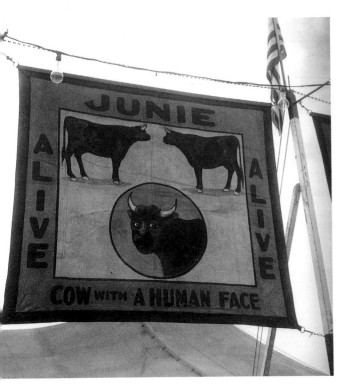

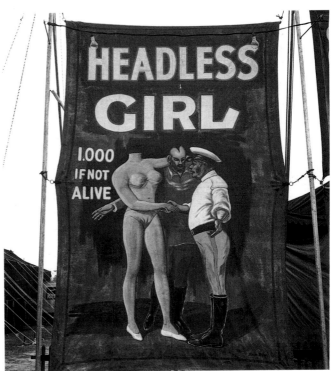

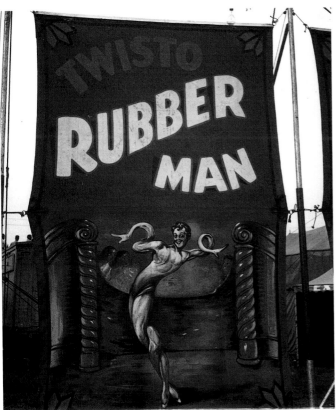

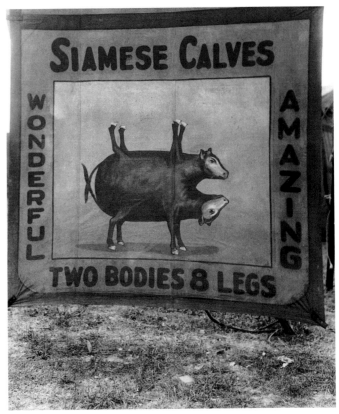

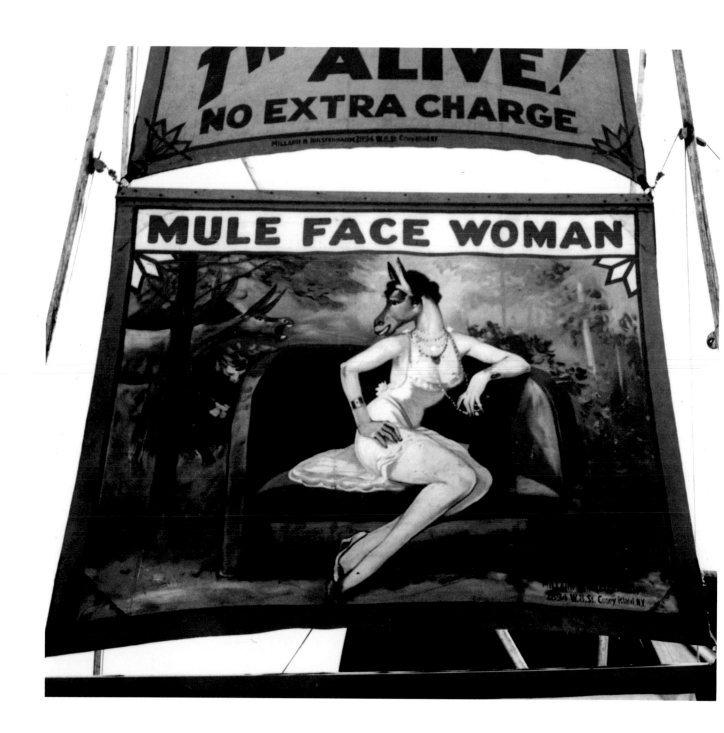

137. *Hypnotized, State Fair / Jackson / 1939*

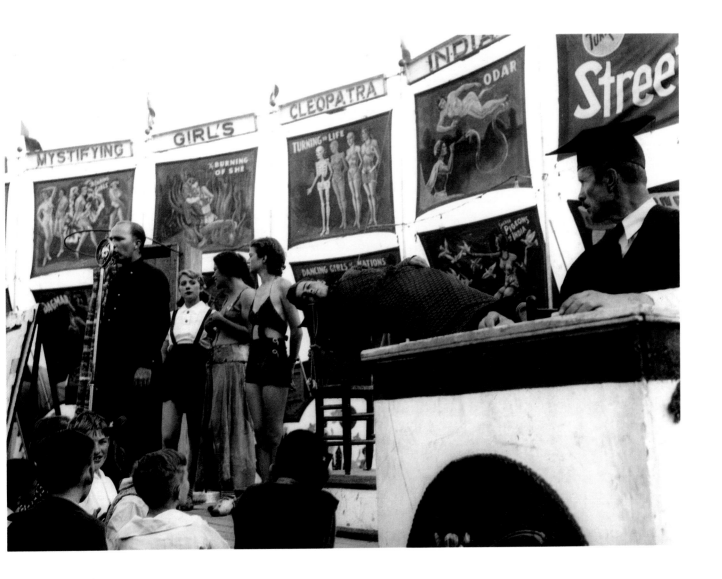

138.
Hypnotist,
State Fair /
Jackson / 1939

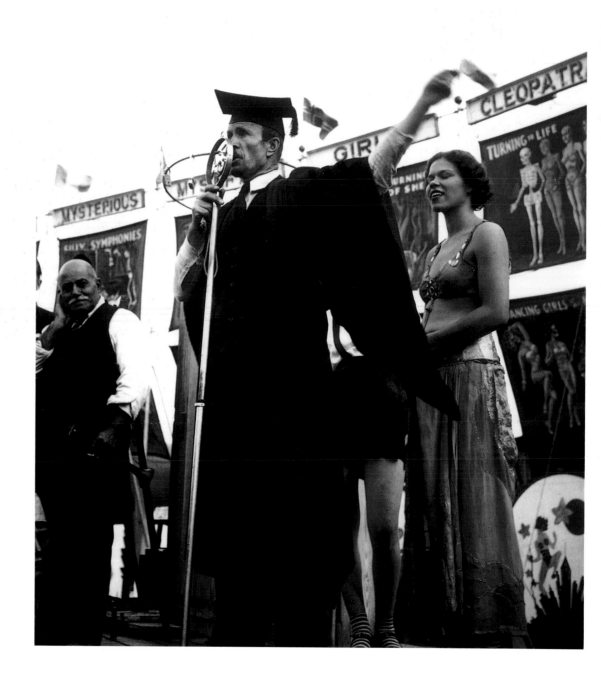

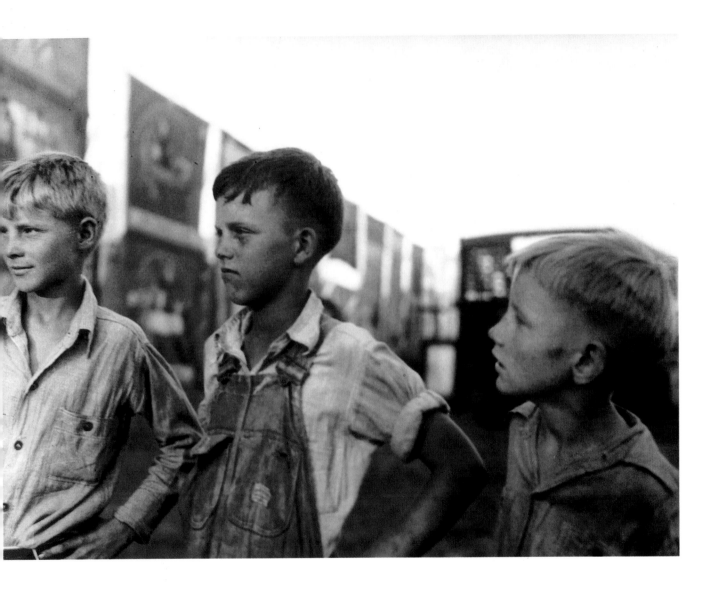

140. Sideshow wonders, State Fair /

Jackson / 1939

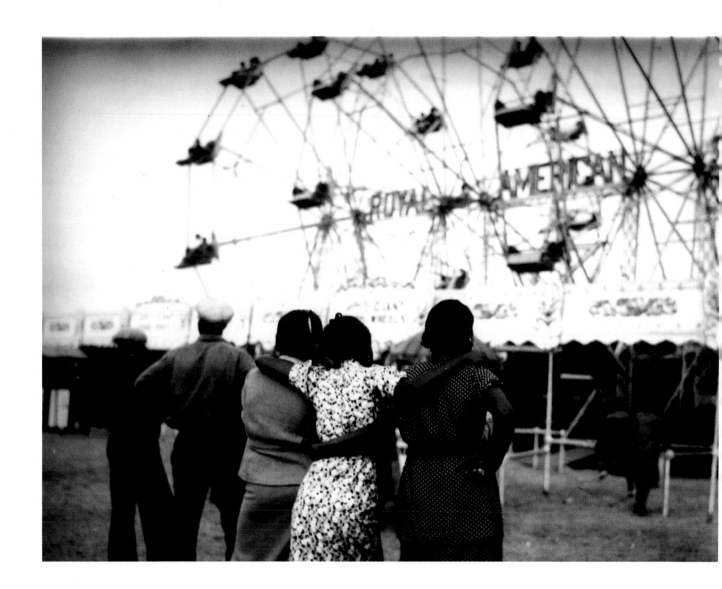

141, 142. *Death defying, State Fair /*
Jackson / 1939

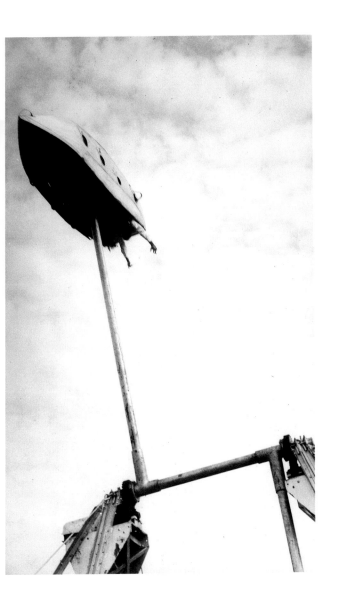

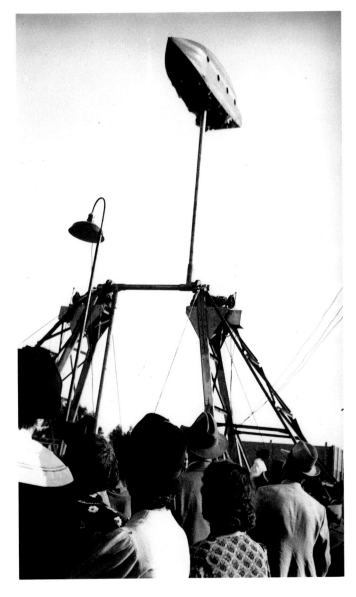

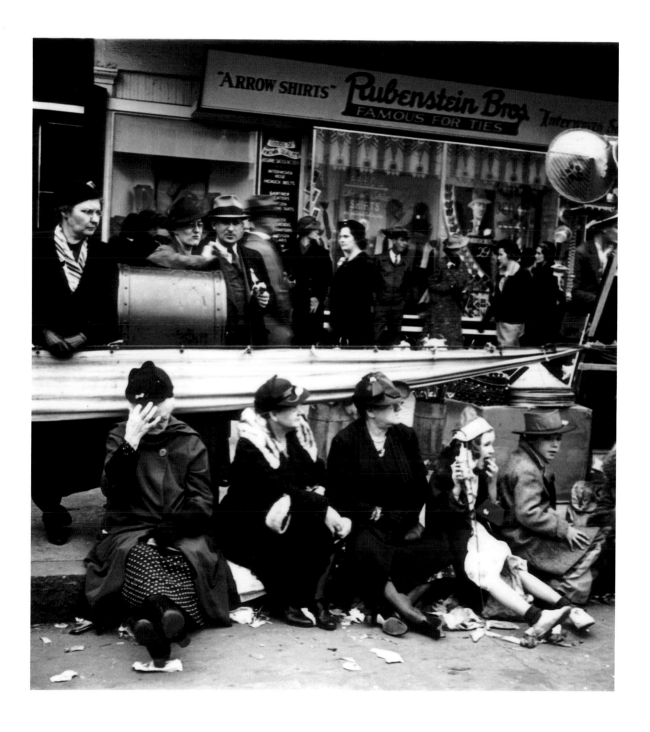

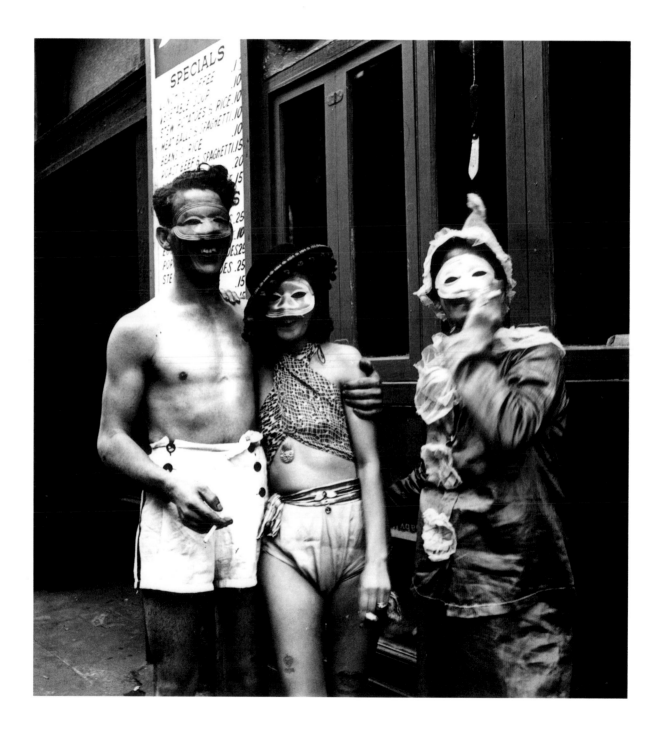

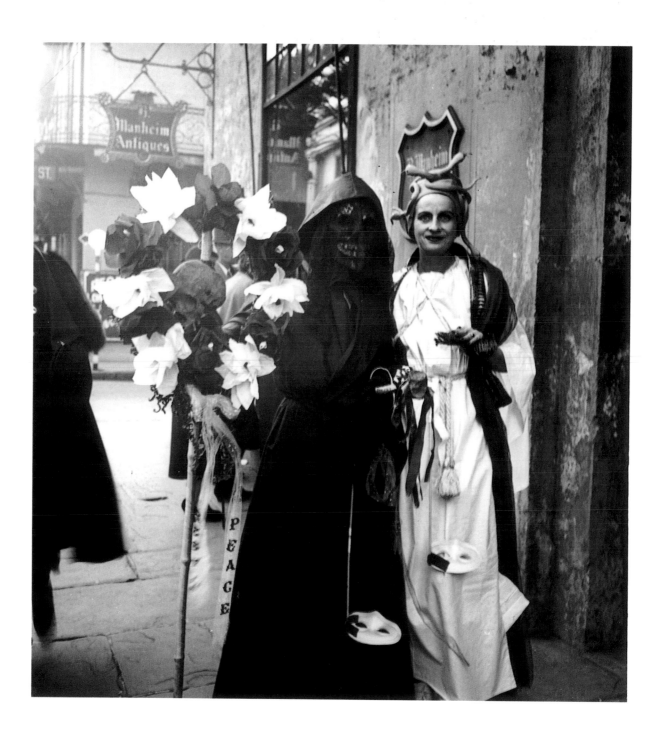

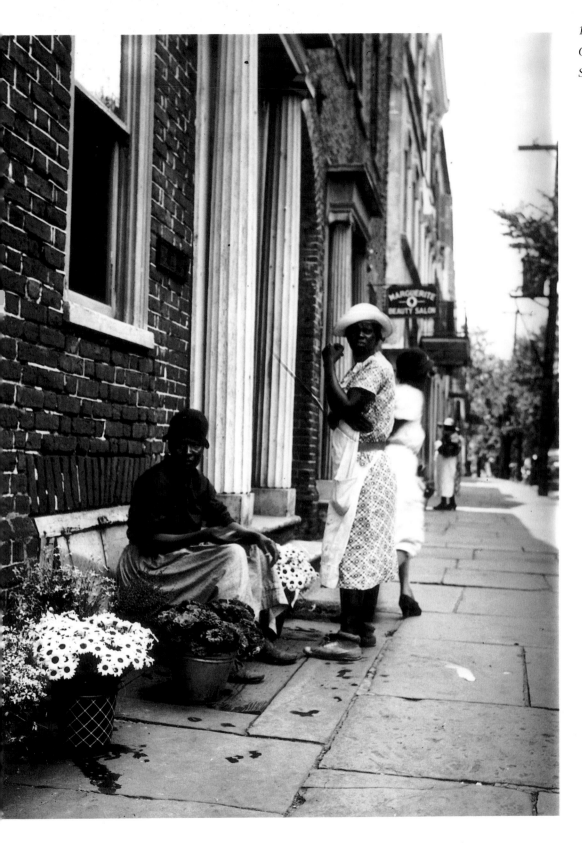

151. East Side / New York City / 1930s

152. Union Square / New York City /

1930s

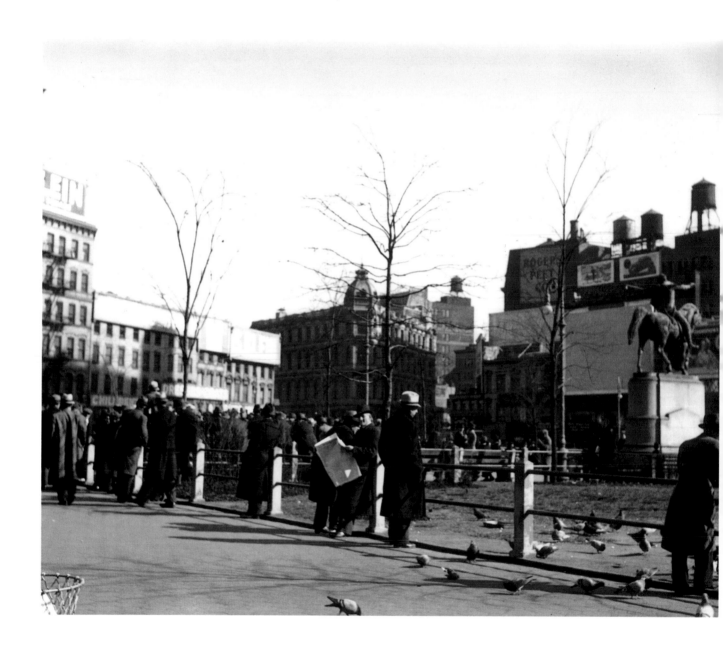

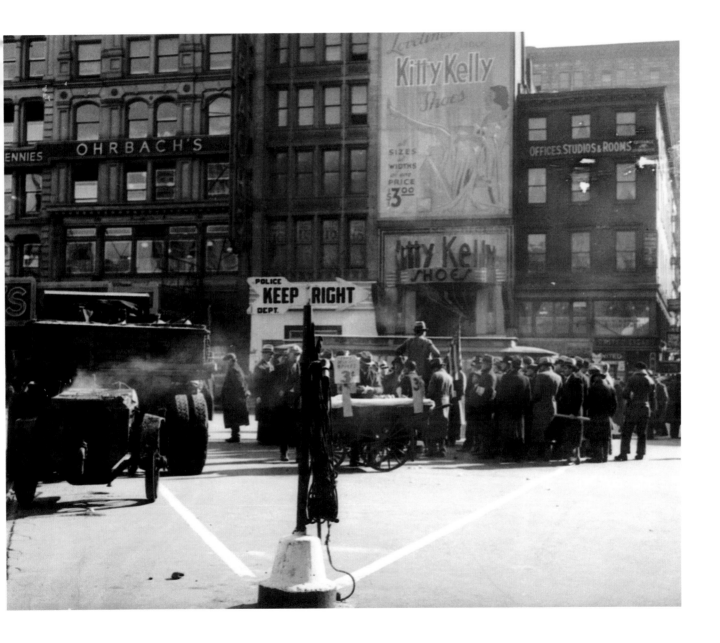

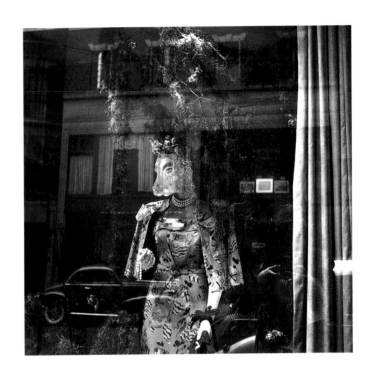

154. *Union Square / New York City /*
1930s
155. *Hattie Carnegie show window / New York City /*
1940s

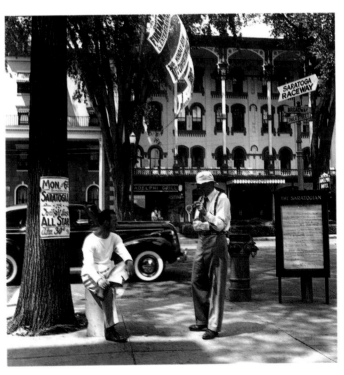

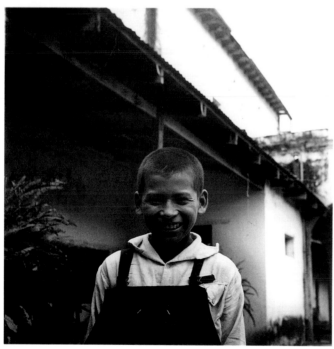

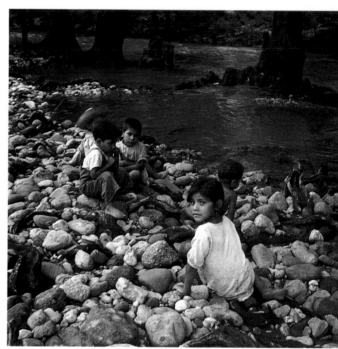

161, 162, 163, 164. Mexico / 1936

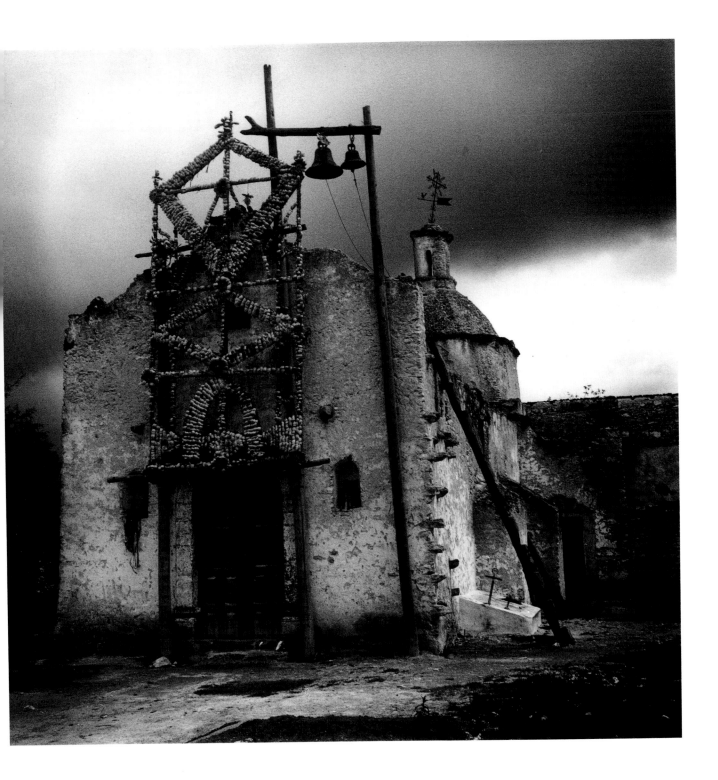

165. Mexico / 1936

166. *England / 1954*

167. *Monk's House, Rodmell / England /*
1954

168. *The River Cam / Cambridge / 1954*

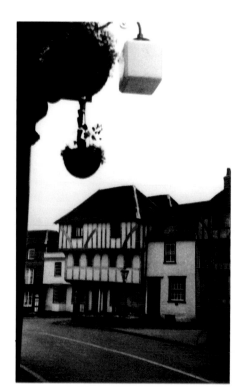

169. England / 1954

170. Peterhouse / Cambridge / 1954

171. Harlech Castle / Wales / 1956

173. Wales / 1956

172. Wales / 1956

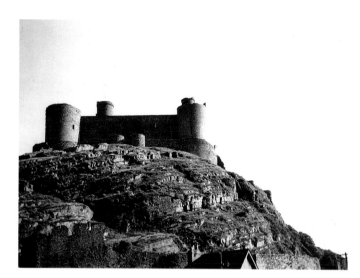

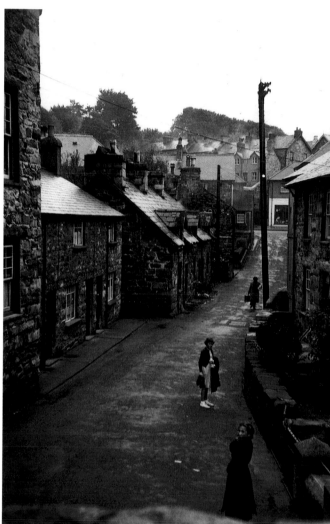

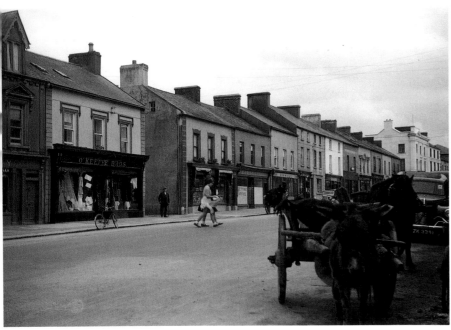

176, 177. Mitchelstown / Ireland / 1950s

178. Ireland / 1950s

179. Power's Court / Ireland / 1950s

180. Ireland / 1950s

181. Kilcolmen Castle / Ireland / 1950s

182, 183. Ireland / 1950s

184. *Bowen's Court, County Cork /*
Ireland / 1950s
185. *"Lambs' drawing room" / Bowen's*
Court, County Cork / Ireland / 1950s
186. *Bowen's Court, County Cork /*
Ireland / 1950s

187. Bowen's Court, County Cork /
Ireland / 1950s

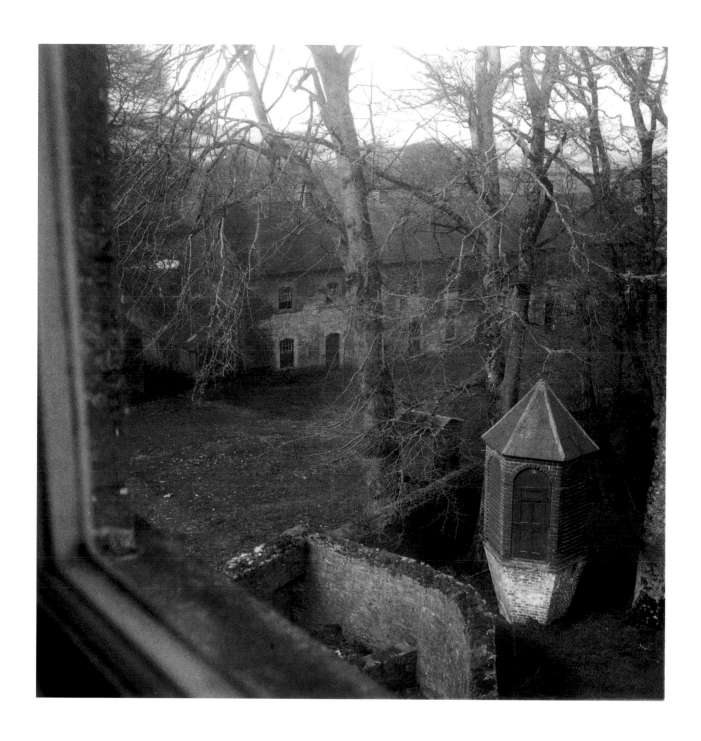

188, 189. San Lorenzo / Italy / 1949

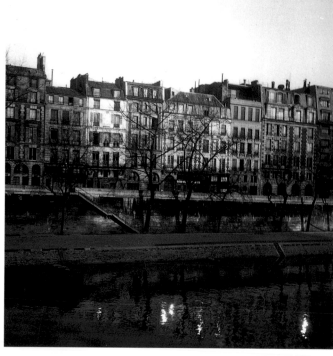

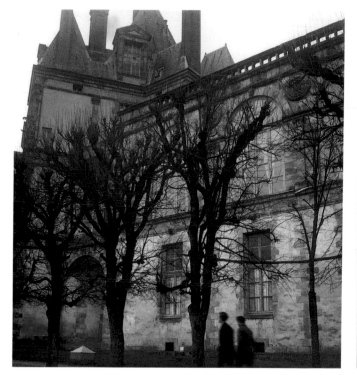

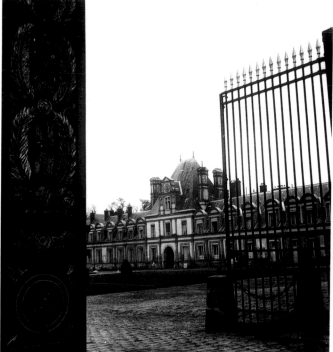

190. *Notre Dame / Paris / 1949*

191. *Paris / 1949*

192. *The Seine / Paris / 1949*

193. *Paris / 1949*

194. *The Seine / Paris / 1949*

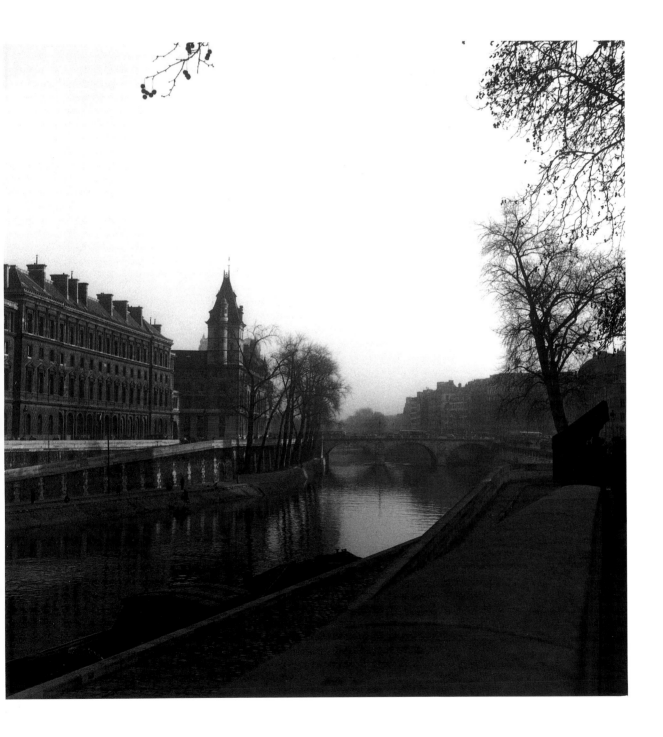

195, 196, 197. Mardi Gras / Nice / 1949

198. Mardi Gras / Nice / 1949

199. *Diarmuid Russell / Katonah, N. Y. /*
1940s

200. *John Woodburn / Yaddo / 1940*

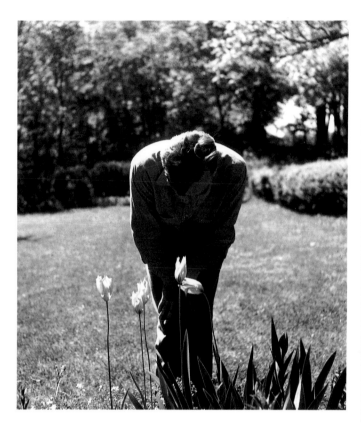

201. *Diarmuid and Rose Russell /*
Katonah, N. Y. / 1940s
202. *John Woodburn and Pamela Russell /*
Katonah, N. Y. / 1940s

203. *Katherine Anne Porter / South Hill Farm, near Saratoga Springs / 1940*
204. *Katherine Anne Porter / Saratoga Springs, N. Y. / 1940*

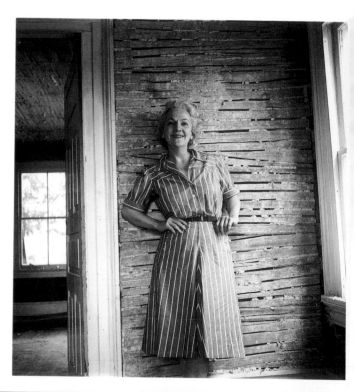

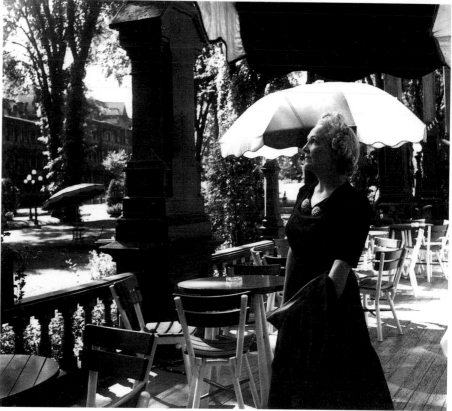

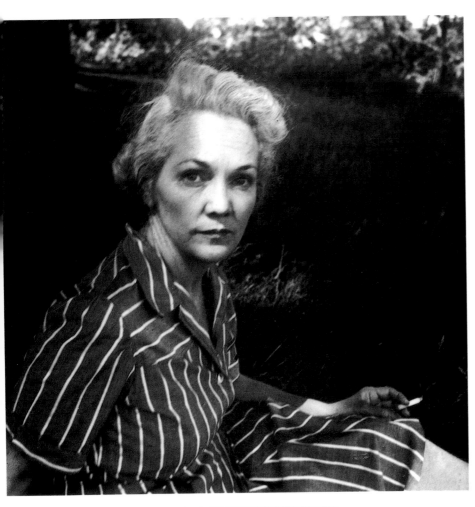

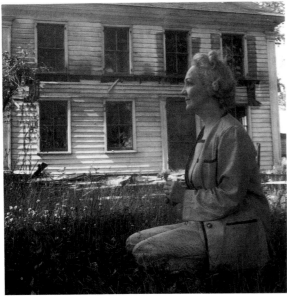

205. Katherine Anne Porter / Yaddo / 1940

206. Katherine Anne Porter / South Hill Farm, near Yaddo / 1940

207. Karnig Nalbandian / Yaddo / 1940

208. José de Creeft / Yaddo / 1940

209. Eddy Sackville-West / Ireland /
1950s

210. Elizabeth Bowen / Ireland / 1950s

*211. Mary Lavin with daughters Elizabeth
and Valentine / County Meath,
Ireland / 1950s*
212. Mary Louise Aswell / Paris / 1949

213. *Barbara Howes, William Jay Smith,*

John Robinson / Siena / 1949

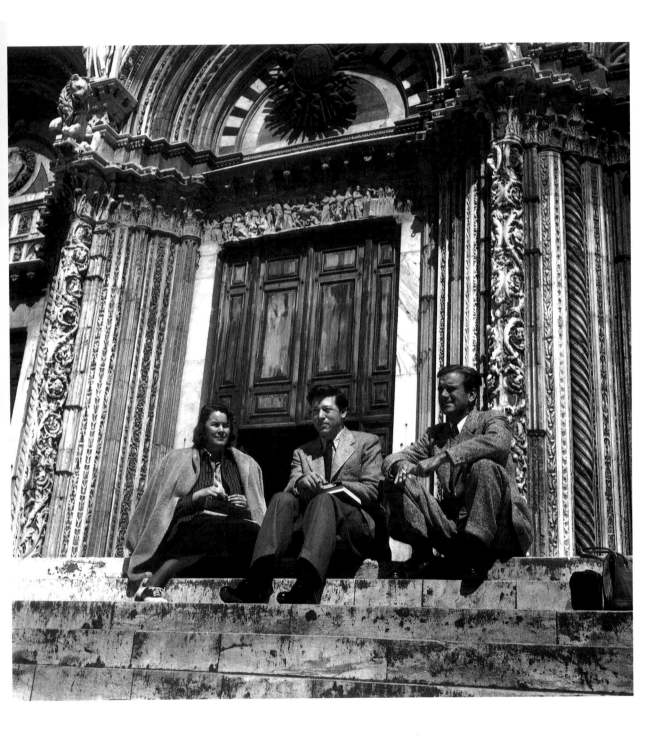

214. Cleanth Brooks and Tinkum Brooks /
Natchez Trace / 1985

215. Sir V. S. and Lady Pritchett /
Savannah, Ga. / 1985

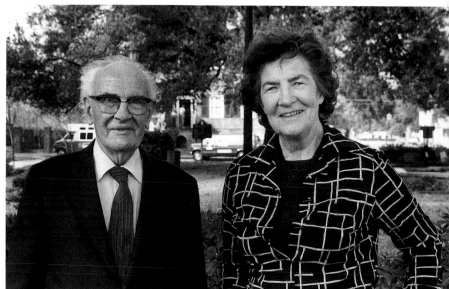

217. George Cooper / Jackson / 1930s

218. Hubert Creekmore / New Orleans / 1942

219. Frank Lyell, Hubert Creekmore, Rosa
Wells, Hildegarde Dolson / Westchester
County, N. Y. / 1940s

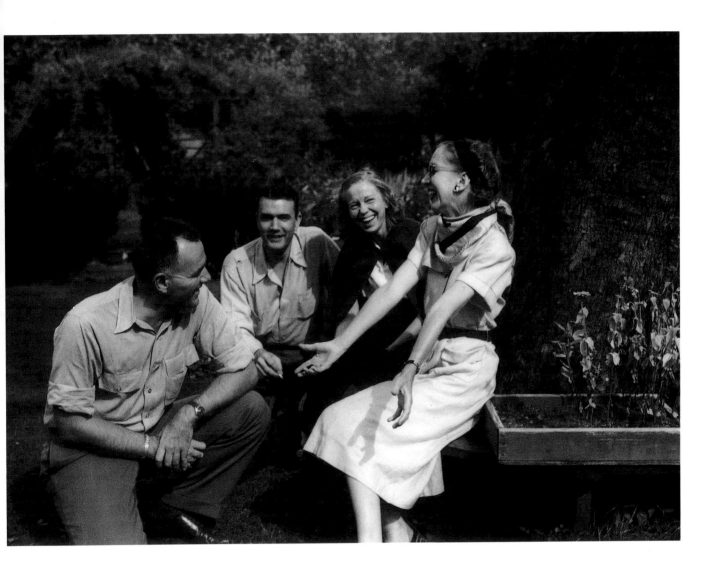

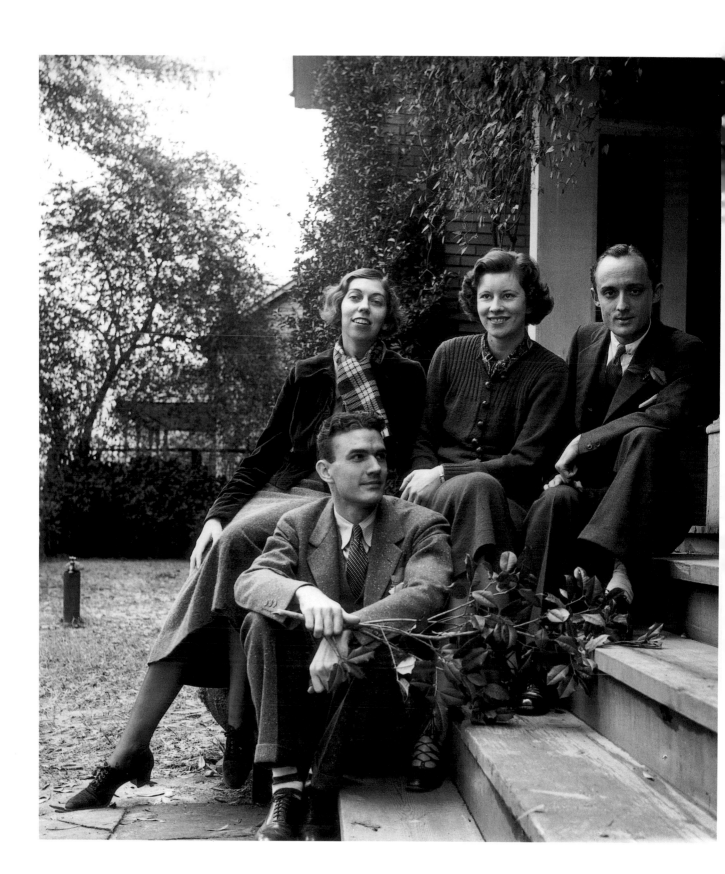

220. Eudora Welty, Hubert
Creekmore, Margaret Harmon, and
Nash K. Burger / Brown's Wells,
Miss. / 1930s

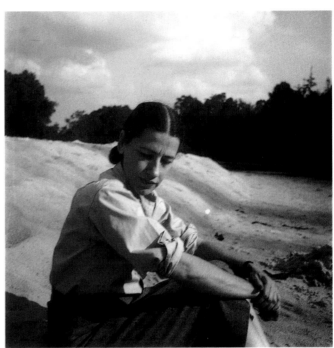

221. Willie Spann / Jackson / 1930s
222. Helen Lotterhos / Jackson / 1930s

223. *Edward Welty and Elinor Welty /*
Jackson / 1940s

224. *Mittie Creekmore Welty and Walter*
Welty / Jackson / 1940s

225. *Chestina Andrews Welty / Jackson /*
1950

226.
Chestina
Andrews
Welty and
Christian
Webb Welty /
Jackson / 1927

In the Pictures of Family and Friends

Mary Louise Aswell, fiction editor, *Harper's Bazaar*

Elizabeth Bowen, writer

Cleanth Brooks, scholar and literary critic

Tinkum Brooks, wife of Cleanth Brooks

Nash K. Burger, editor, *New York Times Book Review*

George Cooper, architect, Jackson

José de Creeft, sculptor

Hubert Creekmore, writer, Jackson and New York

Hildegarde Dolson, writer

Lehman Engel, composer, conductor, writer

Margaret Harmon, friend of EW, Jackson

Barbara Howes, poet

Mary Lavin, writer

Helen Lotterhos, painter, Jackson

Frank Lyell, professor, University of Texas, Austin

Karnig Nalbandian, etcher

Katherine Anne Porter, writer

Sir Victor Pritchett, writer

John Robinson, lifelong friend of EW, Mississippi and Italy

Diarmuid Russell, EW's literary agent

Pamela Russell, daughter of Diarmuid Russell

Rose Russell, wife of Diarmuid Russell

Eddy Sackville-West, writer

William Jay Smith, poet

Willie Spann, lifelong friend of EW, Jackson

Rosa Wells, lifelong friend of EW, Jackson and New York

Christian Webb Welty and Chestina Andrews Welty, EW's parents

Edward Welty and Elinor Welty, EW's brother and sister-in-law

Mittie Creekmore Welty and Walter Welty, EW's sister-in-law and brother

John Woodburn, EW's first editor

Library of Congress Cataloging-in-Publication Data

Welty, Eudora, 1909–
 Eudora Welty: photographs / Eudora
Welty; foreword by Reynolds Price.
 p. cm.
 ISBN 0-87805-450-2 (alk. paper).
 ISBN 0-87805-529-0 (pbk. : alk. paper)
 1. Photography, Artistic. 2. Mississippi—
Description and travel-1981—Views. I.
Title. II. Title: Photographs.
TR654·W422 1989
779′.092—dc20 89-35218 CIP